little book of

SEOUL

style

Copyright © 2024 Dianne Pineda-Kim

The right of Dianne Pineda-Kim to be identified as the Author of
the Work has been asserted by her in accordance with the
Copyright, Designs and Patents Act 1988.

First published in 2024 by Welbeck
An Imprint of HEADLINE PUBLISHING GROUP

1

Apart from any use permitted under UK copyright law, this publication
may only be reproduced, stored, or transmitted, in any form, or by any
means, with prior permission in writing of the publishers or, in the case of
reprographic production, in accordance with the terms of licences issued
by the Copyright Licensing Agency.

Every effort has been made to fulfil requirements with regard to reproducing
copyright material. The author and publisher will be glad to rectify any
omissions at the earliest opportunity.

Cataloguing in Publication Data is available from the British Library

ISBN 978 1 8027 9780 0

Printed and bound in China by Leo Paper

Headline's policy is to use papers that are natural, renewable and recyclable
products and made from wood grown in well-managed forests and other
controlled sources. The logging and manufacturing processes are expected to
conform to the environmental regulations of the country of origin.

HEADLINE PUBLISHING GROUP
An Hachette UK Company
Carmelite House
50 Victoria Embankment
London EC4Y 0DZ

www.headline.co.uk
www.hachette.co.uk

DIANNE PINEDA-KIM

little book of

SEOUL
style

The Fashion Story of the Iconic City

WELBECK

CONTENTS

INTRODUCTION

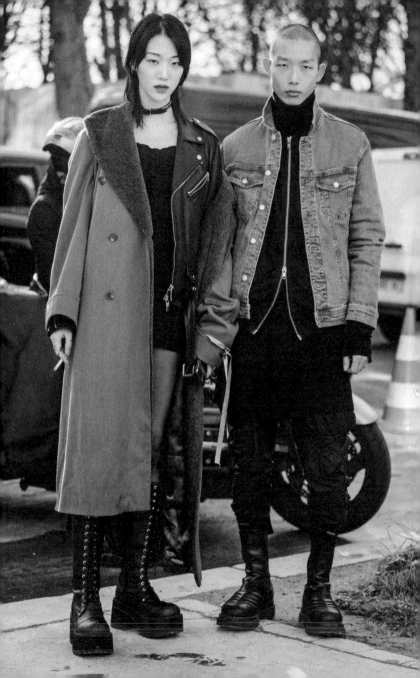

WHAT iS K-STYLE?

In Korea there's a catchphrase that rules the streets and the runway: *kku-an-kku* fashion, a clever slang that translates to "dressed up like you didn't care, but you did care". This effortless yet intricate style embodies the art of minimalism with a twist, as though the wearer nonchalantly threw on their outfit, but in reality every element has been thoughtfully considered.

And nowhere is this style more prominent than on the trendy streets of Apgujeong Rodeo and the bustling university streets of Seoul, where you'll encounter a young Korean crowd that embodies this "less is more" ethos: men exude a laid-back vibe with plain shirts, loose-fit jeans and stylish sneakers, while women flaunt a chic summer look adorned with miniskirts, cropped tees and platform boots.

As winter descends, another layering challenge arises, and Koreans unveil their creativity through subtle, skilful styling, often showcasing leather as a centrepiece. The simplicity of colours is striking – whites, blacks and beiges rule supreme – but don't be fooled: most Koreans wear an eclectic mix of high and low fashion, with designer and ready-to-wear pieces carefully coordinated to create a distinctive *kku-an-kku* outfit with only one statement item or accessory to complete the look.

Korean supermodels Sora Choi and Xu Meen capture street style photographers' attention for their cool off-duty outfits after the Sacai show in Paris, France.

What makes this style fascinating, however, is the way the pieces come together. Each outfit is intentional, whether it's a crisp button-down shirt paired with slacks or sporty casualwear. This unique *kku-an-kku* fashion aesthetic and intentionality lie at the heart of Korean style, mirroring the cultural values of their society. In Korea, where respect and hierarchy hold great significance, humility, sensitivity and politeness are woven into their attire, transcending mere aesthetics. For Koreans, it's not about flaunting: it's about presenting themselves in the best, most genuine way possible.

"Qualities like simplicity, understatedness and the poetic nature of blankness truly embody the essence of the Korean aesthetic," remarked Kimhēkim, a renowned Korean designer. In an interview for this book, he highlighted his expertise in crafting modern, minimalistic creations that artfully combine sleek, contemporary lines with the graceful silhouettes of traditional Korean garments. He also stressed, however, that "everyone around the world is inspiring and being inspired by each other."

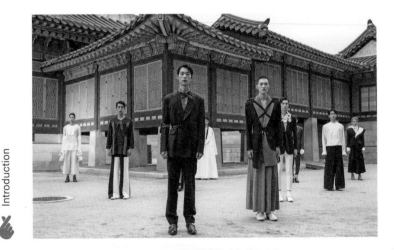

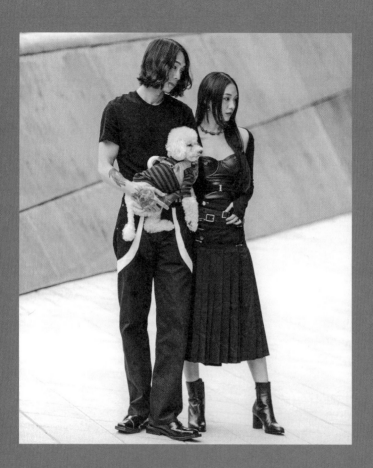

Above: A couple, along with their beloved pet, don matching all-black ensembles as they make an appearance at Seoul Fashion Week. In South Korea, the popular trend known as the "couple look" is widely embraced, where couples sport matching or subtly coordinated attire. (Photo by Jay Lim)

Opposite: Established by Chang Kwang Hyo, Caruso is a South Korean men's fashion label that is recognized for infusing classic Korean elements into modern men's suits, featuring innovative touches. Here, models present the Spring/Summer '22 Collection at Changgyeong Palace in Seoul.

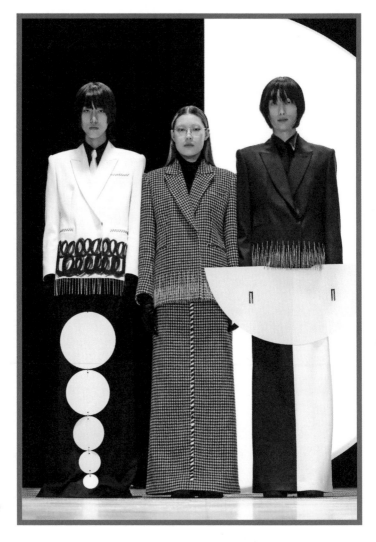

Hanacha Studio is a globally recognized fashion brand renowned for its stylish and understated designs inspired by art, architecture and interior design, blending avant-garde elements into everyday fashion.

Korean fashion, then, is both local and global. It encompasses this effortless minimalism in a dynamic duality, where quiet restraint, understated tastes and an unpretentious sense of style coexist with bold colours, playful designs and experimental silhouettes. This vibrant side stands in stark contrast to the classic *kku-an-kku* fashion. We witness this vibrant spirit in the world of K-pop music, where girl groups and boy bands don colourful and mismatched ensembles, seamlessly blending Western, traditional and contemporary elements. Amidst this psychedelic explosion of colours and innovative looks, coherence and intentionality remain the guiding principles. The convergence of these distinct elements defines the captivating allure and identity of Korean fashion.

Within the realm of K-pop the dynamic attires serve more than mere spectacle. They convey the character, mood and message of their music. By artfully integrating traditional Korean motifs into their attire, K-pop artists distinctly convey to their worldwide fanbase a resounding declaration: "We are Korean, and we are proud of it!"

Designer Hwang Yi-seul, founder of the modern hanbok (traditional Korean clothing) brand LEESLE, perhaps best explained what sets Korean style apart. "I think it's *jeong-jung-dong*," she says in Korean, words meaning "stillness in movement". "Korean aesthetic has the charm of making opposite things look harmonious together," she says. "Quiet but moving, moving but still." This means that Korean fashion continually evolves while staying true to its roots. From traditional to trendy, hanbok to modern casualwear, the core of Korean identity is interwoven into every locally produced garment – be it through subtle elements like fabric and silhouette to more explicit features such as Korean traditional symbols, patterns and prints.

Staying culturally rooted while embracing new trends is no easy feat. But Korea, a digital powerhouse and an ultra-modern country where almost everything can be efficiently done online, achieves this by adapting fashion trends at a remarkable pace. This attribute, also mentioned by editor Claire Marie Healy in *AnOther Magazine*, is influenced by their ppalli-ppalli culture, which translates to "quick, quick". Whether it's ordering food or getting paperwork done, everything happens swiftly, including the addition of new styles straight off the runways. This advanced shopping infrastructure, whether online or offline, has made fashion widely and easily accessible in Korea.

Koreans not only champion their own brands but seamlessly blend the latest Western trends and designer labels into their wardrobes, all done in the *ppalli-ppalli* style. However, this rapid pace doesn't compromise their attention to detail. Their unique combination of quickness and the *kku-an-kku* mindset, where every element is thoughtfully considered, results in a contemporary look. It's this distinct approach that continually updates their fashion while preserving their Korean identity, creating a captivating fusion that sets them apart on the global fashion stage.

This conscious national pride, evident not only in fashion but in every aspect of their lives, stems from Korea's journey as a nation that now proudly stands as one of the world's most influential fashion leaders. But one comes to wonder: amidst the surge of Western influences, the universality and interconnectedness of fashion, how exactly did Korea manage to preserve its distinct essence while staying ahead with its cutting-edge styles? The journey of Korea's fashion ascendancy is as captivating as the styles they create, and we'll dive deeper into their fascinating evolution in the pages to come.

Beyond Closet, designed by Ko Tae Yong, is a men's fashion label
that finds its inspiration in classic American preppy fashion, infusing
it with a contemporary, effortless and cool Korean twist.

KOREAN NATIONAL ATTIRE: THE HANBOK

UNRAVELING THE HANBOK

With its voluminous silhouette, vibrant colours and profound symbolic meanings, the hanbok has become Korea's national attire, representing the status, values and traditions of its people through intricate designs, embroidery and textiles. The term *"hanbok"* translates to "Korean clothes," originating when a distinction was made between Korean clothing and Western attire. This traditional attire underwent transformations throughout various dynasties, known as the Three Kingdoms in Korea (57 BCE–668 CE). From the elegant Silla dynasty to the refined Baekje and the illustrious Goguryeo era, the hanbok's evolution tells a tale of Korea's innovation and tradition.

During the Silla dynasty, the hanbok was designed with elaborate garments adorned with embellishments and vibrant colours, symbolizing class and nobility. In the Baekje kingdom, the hanbok embraced a more relaxed yet opulent style, reflecting a more open and cosmopolitan society. In the illustrious Goguryeo dynasty, the hanbok exuded an aura of regal splendour. Adorned with lavish embroidery and ornate designs, the hanbok symbolized the opulence, sophistication and grandeur of the wearers.

A portrait of an unmarried woman by an unknown artist (approximately 1920–40). The diverse styles of the hanbok historically represented an individual's social status within Korean society, particularly during the Joseon dynasty.

Korean National Attire: The Hanbok

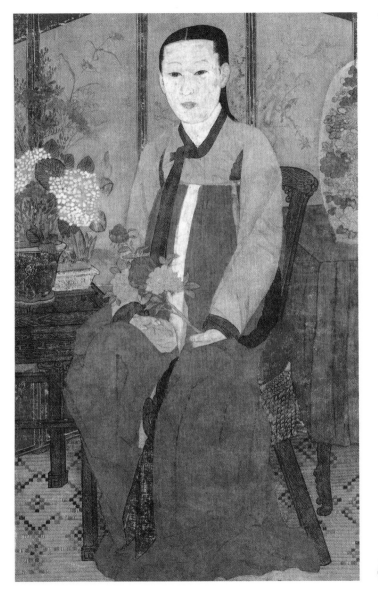

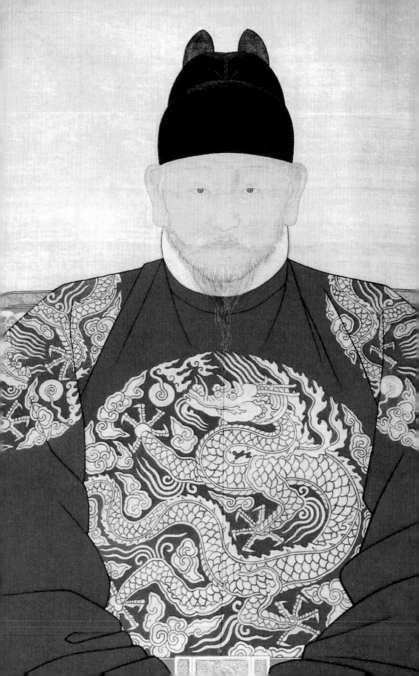

Regrettably, the comprehensive evolution of the hanbok lies beyond the scope of this book. Instead, our focus narrows to the Joseon dynasty (1392–1897), a pivotal era that solidified all the elements of prior kingdoms and culminated in the quintessential hanbok we recognize today.

The Joseon dynasty witnessed a refined revolution in hanbok design, characterized by its clean lines and subdued colours, embodying the ideals of modesty, grace and virtue. The hanbok consists of several elements, including the *jeogori*, an upper garment for both men and women, a *chima* or skirt for women, and *paji* (trousers) for men. It exudes a timeless ethereal beauty, evident in its graceful flow with every movement and the meticulously crafted details that endure to this day. However, the hanbok holds significance beyond mere aesthetics. It embodies the etiquette, culture and socioeconomic status of its wearers, directly reflecting the prevalent Confucianism values of the time, which emphasized maintaining social roles to achieve societal harmony.

This hierarchical structure in society was reinforced in the people's way of dressing. The selection of special designs and silk fabric was reserved for royalty and the upper class. Bright colours were worn by the elite and the scholarly class, which included blue, white, red, black and yellow, representing the five colours of nature. In children's attire, these colours created balance with nature, signifying blue for spring, white for autumn, red for summer, black for winter, and various shades of yellow symbolizing the land.

A portrait depicts Taejo of Joseon, the founder and initial monarch of the Joseon dynasty. The hanbok in the painting conveyed the rank of individuals at the royal court, with dragon-embroidered circular badges for the king and his heirs.

Various details on the hanbok denoted rank and status within the royal court. Circular badges with dragon embroidery were reserved for the king and his heirs, while phoenixes were designated for queens, and flowers for princesses.

Conversely, a distinct category of hanbok was specifically designated for the *kisaeng* (sometimes spelled *gisaeng*) – women extensively trained in diverse arts to entertain. Although proficient in music, singing, dance, poetry, painting and needlework, among other talents, the *kisaeng* faced societal prejudices. Despite this, they emerged as trendsetters of their era, adorning hanbok in diverse styles, colours, lengths and eye-catching accessories. Hanbok designer Kim Hye-soon underlines this unique influence, telling the *Korea Times*, "In terms of style, *kisaeng* were not subject to rules and regulations, and were fashion leaders of their time."

Among the common folk, garments made from hemp, ramie and linen were prevalent. Simple styles with little to no design were preferred in their daily clothing, which reflected the neo-Confucian preference for austerity in the later part of the Joseon dynasty.

Notably, every aspect of the hanbok, including the accompanying accessories, carried multiple meanings. For instance, the *daenggi* was a fabric ribbon tied to a single braided hair, indicating that a woman was unmarried, whereas a traditional hairpin called *binyeo*, worn on the lower bun, was a symbol worn by married women. The *binyeo*'s shape varied and represented wealth, health and prosperity. Additionally, the *norigae*, a type of tassel or accessory with silk threads hanging from the upper part of the hanbok, served as a charm to bring good luck to the wearer. As for men, they donned their hanboks with hats not only to shield their faces from the sun, but also indicate their social standing as commoners, royal ministers or scholars.

Kisaeng, skilled entertainers of ancient Korea, were
renowned trendsetters of their era due to their
vibrant hanboks and distinctive accessories.

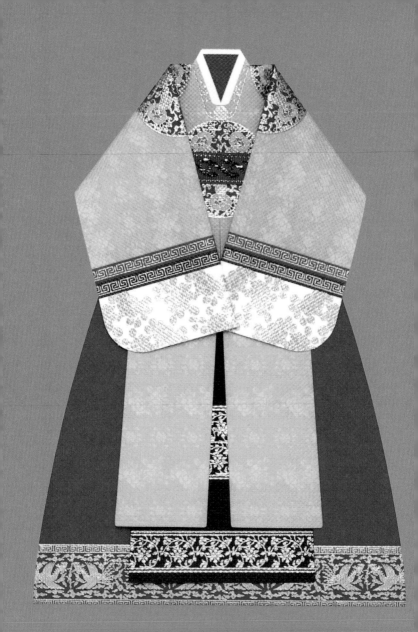

The prints, colours, embroidery and patterns on the hanbok often depicted images of animals, flowers and other elements of nature, reflecting the deep reverence Koreans held for the natural world and the spiritual realm. They believed that spirits guided their daily lives, and by incorporating such symbolism into their clothing, they sought protection from benevolent spirits while also symbolizing their dignity.

In contrast to typical clothing that conforms to the body's shape, the hanbok's softness and loose fit are designed for comfort and practicality. This showcases the ingenuity and intentionality of Korean design, where clothes are meant to serve the body rather than the other way around. Throughout a person's life, the hanbok is woven with layers of meanings, with each detail conveying an expression of Korean culture.

"Hanbok to Koreans is more than just a piece of clothing," said Jung Young-hwan, an official from the Cultural Heritage Administration (CHA), in an interview with *Korea JoongAng Daily*. "It's an important medium through which they show respect and express wishes for good health and peace, which makes it an important intangible asset."

In ancient times, the hanbok symbolized the foundation and growth of Korea, but its gradual obsolescence was inevitable. There are several historic accounts that detail the decline of wearing hanbok as Korea opened its doors to the world. Times were changing, and the cultural reforms that took place during the Joseon dynasty played a significant role in this transformation. As Korea's ports opened, the once staunchly traditional Koreans were exposed not only to an influx of Western products but also to new ideas. The Gabo Reform

The hanbok's prints, colours, embroidery and patterns frequently featured depictions of animals, flowers and elements from nature, particularly when worn by individuals in the royal palace.

of 1894 to 1896 further contributed to the weakening of class distinctions. It was the first step towards the "modernization" of Korea.

Consequently, the emperors compelled their ministers and staff to adopt Western suits, leading to the abandonment of certain rigid styles for men. This reform was also applied to the hanbok, which was simplified and modified to increase ease of movement, paving the way for women's empowerment and social mobility. Despite the influence of Western styles, the hanbok remained a symbol of cultural identity and pride, carrying the rich heritage of Korea through the ages.

Fast forward to 1968... a trailblazing hanbok designer laid the foundation for the modernization of this traditional attire when she started her hanbok business in Seoul. Lee Eun-yim, renowned by her brand name Lee Rheeza, is credited as the pioneer in altering the skirt and refining various aspects of the hanbok to tailor it to individual customers. During that era, hanbok production was primarily carried out by married women, who were regarded more as garment workers than designers. However, it was Lee who boldly embraced the title of "hanbok designer", even before such a term was commonly used. She designed for Korean diplomats, first ladies, top celebrities, and made the first "marketable" hanbok in chic and elegant designs that became the standard.

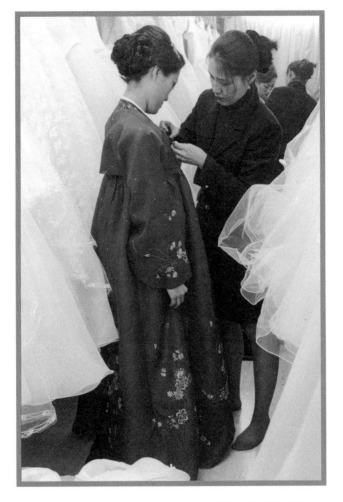

Above: Even as Korean brides began to adopt Western-style white bridal gowns, it remains customary for the groom's or the bride's mother and certain guests to don traditional hanbok attire.

Opposite: The *jeogori* serves as the basic upper garment of the hanbok, a term used for this garment worn by both men and women.

At present, wearing the hanbok is reserved for special occasions. Whether it's celebrating a child's first birthday, partaking in a wedding ceremony, or observing cherished holidays like Chuseok (mid-autumn harvest festival) and Seollal (Lunar New Year), the tradition of wearing the hanbok endures to this day.

However, the privilege of wearing the hanbok is not limited solely to Koreans. Tourists visiting Korean palace destinations in Seoul or exploring *hanok* (traditional Korean houses) villages in other regions, such as Jeonju and Gyeongju, also have the opportunity to experience this cultural attire. Many of these places offer hanbok rental services, allowing visitors to immerse themselves in the rich heritage and beauty of Korean clothing.

> **"For many people, wearing the hanbok is a way of showing respect and exhibiting a special version of oneself."**

"The whole experience of wearing hanbok is, in itself, culture as it involves unique etiquette and formalities and is executed differently for different occasions – ceremonies and rituals or traditional holidays or recreational events," Jung, an official from CHA who seeks to protect the tradition of wearing hanbok, said. "There's even a saying: 'What you wear defines who you are.' For many people, wearing hanbok is a way of showing respect and exhibiting a special version of oneself."

The *hye* shoes are low-rise and are typically designed to mirror the natural curve of the *jeogori* sleeve hem and the pointed tips of the Korean socks known as *beoseon*, which are worn with the hanbok.

Korean National Attire: The Hanbok

KOREAN
FASHiON
THROUGH
HiSTORY

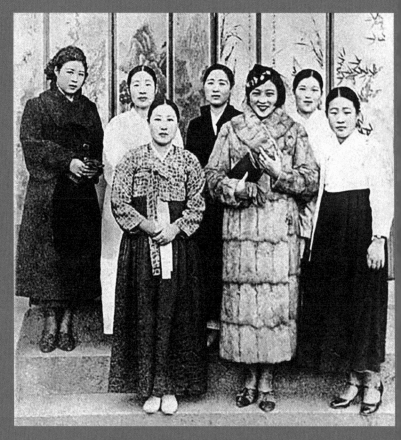

This photograph showing Choi Seung-hee, the first female dancer in colonial Korea to perform outside of the country, dressed in Western-style attire, including a fur coat, while encircled by other women wearing hanbok, signified the beginning of Koreans opening up to Western styles.

THE BLOOMING PERIOD: THE CAEHWAGI

While the nation was establishing a strong foundation for its distinct identity, the period of Japanese colonial rule from 1910 to 1945 suppressed every form of creative, social and traditional expression. The Japanese authorities banned the use of the Korean language in schools and public spaces and imposed forced labour to serve their empire. Moreover, they confiscated the most powerful symbols of Korean sovereignty, including the palaces, Korean art, history, literature and ancient treasures, with the intention of erasing Korea's historical memory.

Wearing of the hanbok, one of the main identifiers of Korean culture, was also banned. Men started wearing Western-style suits, while women started wearing hanboks that were devoid of designs or emblems with significant Korean meanings. The rest of the nation wore white to convey their feelings of protest and distress against the occupation. The white hanbok, in particular, held great symbolic importance for Koreans throughout history, symbolizing purity, solidarity and resistance during times of political turmoil. Even in ancient times the majority of citizens predominantly wore white and were known as the *baeke minjok* – people of white clothes.

According to author Kim Seok-hee, who made a study of the Colored Clothes Campaign, the Japanese authorities imposed a ban on wearing white colour, deeming it a symbol of "weak Korea," which compelled Koreans to adopt dyed attire.

This prohibition not only led to the disappearance of white traditional clothes but also marked the eradication of the custom itself.

Meanwhile, a major change was taking place as a new breed of educated Korean men and women emerged. This generation, from the period spanning from the late nineteenth century, is known as the "Gaehwagi", which aptly translates to "bloom". Just like a flower, Korea, once closed like a bud, now embodied the readiness to absorb diverse external influences.

Because of this period, the gates of opportunity swung open for members of elite families, granting them the chance to study abroad and immerse themselves in Western culture, including its distinctive fashion. This newfound exposure paved the way for a stylish revolution known as the "Gaehwagi style", aptly named after Korea's "blooming period".

Picture the allure of the "modern men and women look", where midi-length dresses were elegantly paired with

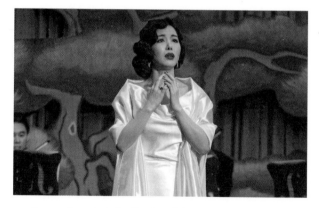

A scene from *Pachinko*, *The New York Times* bestseller turned drama series set in the Japanese colonial period in Korea, features a soprano wearing a Western-style silk gown.

matching lace gloves and fascinators, exuding an air of sophistication for the women. As for the men, they adorned themselves in the sleek and dapper three-piece suits, perfectly tailored to showcase their newfound sense of refinement.

With each step, this educated class showcased a newfound confidence, taking advantage of the fusion of traditional Korean elements and the influences of the Western world. The Gaehwagi style became a powerful symbol of a nation blooming into a new era, marked by a blend of cultures, aspirations and dreams.

Japan couldn't crush the spirit and the creativity of Korean people. Amidst the uncertain times, ingenuity shone through. This period gave birth to poets, novelists, musicians, performers and fashion designers who expressed resistance and nationalism through art.

In the realm of fashion, Korean fashion history would not be complete without acknowledging Choi Kyung-ja, who is considered as the "mother of Korean fashion". In 1937 she established Eun Jwa Ok, the first Korean couture house, and in the following year, the Hamheung Professional Dressmaking Institute, the first Korean fashion school. She was the first to give a dedicated space for women to shop, a rare occurrence at that time when it was customary for women to shop in men's boutiques.

Choi first rose to mainstream fame in the 1950s for her ready-to-wear couture collections. Maintaining her passion as a fashion educator, she later opened the first charm school for fashion models in 1964 and introduced the initial fashion magazine, *Costume*. Choi Kyung Ja's pioneering work left an enduring legacy in shaping the landscape of Korean fashion and making stylish clothes readily available for women. Her career in fashion spanned 70 years.

THE LIBERATION ERA

After 35 years of Japanese colonial rule, Korea was liberated from Japan on 15 August 1945, in a momentous occasion called Gwangbokjeol, which literally means "Restoration of Light Day". Regrettably, though, the challenges for Korea did not cease then. Following the Second World War the country was partitioned into North and South, and it then from 1950 to 1953 endured the devastating Korean War. Since then, a truce line has persistently separated the two Koreas near the 38th parallel.

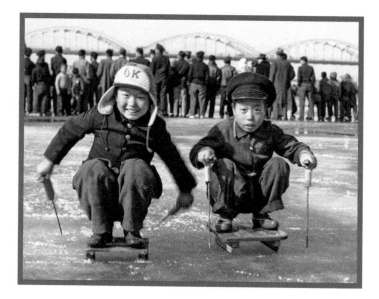

Children wearing clothes made from military uniforms left from the war.

The presence of the US forces at the end of the war in Korea brought in the distribution of relief goods, most of them American products. The aftermath left behind remnants of war, including military vehicles, uniforms, combat boots and various paraphernalia scattered across the South Korean territory.

Despite the scarcity of supplies, the Koreans displayed remarkable resilience and resourcefulness in their efforts to survive the post-war challenges. As Korea and its society underwent gradual reconstruction, the soldiers' uniforms found new life as practical, utilitarian daily wear for the locals. Military jackets in particular were deconstructed and transformed into women's coats during winter. The children wore pantsuits made out of khaki Navy uniforms.

"Despite the scarcity of supplies, the Koreans displayed remarkable resilience and resourcefulness in their efforts to survive the post-war challenges."

Army blankets were ingeniously transformed into various pieces of clothing by dyeing the fabric to change its colour. However, the original "USA" mark on the blankets remained visible, resulting – according to an extensive article by Korean newspaper *Chosun Ilbo*, which illustrated Korea's 70 years of clothing – in several university students wearing clothes that unintentionally bore a US label.

Additionally, there are accounts that narrate how nylon accidentally became a revolutionary fabric in Korea. Left behind by the US, nylon-based parachutes caught the attention of Koreans, who realized that this "mysterious" material

was tear-resistant and highly durable. Other records show that nylon was imported to Korea from another country. But no matter its origin, Korean textile manufacturers began producing their own nylon and incorporated it into the making of socks, shirts, and underwear, significantly transforming the local textile industry. Other fabrics like velvet and silk from neighbouring countries were also becoming popular at that time, signalling the start of Koreans' interest in fashion not only as a way of life but also as a business.

Meanwhile Koreans who had previously migrated overseas began returning to South Korea after the war, introducing styles and fashion pieces that were previously unheard of in the country. Among these new influences were fedora hats, oversized suits, flared dresses, clutches and heels. The Golden Age of Hollywood largely contributed to this influence, with many Korean women emulating Audrey Hepburn's iconic looks from her movies. Notably, a new hairstyle, based on the perm, emerged among women during this period. The influx of these fresh fashion trends played a significant role in diversifying and modernizing the fashion scene in South Korea.

"Koreans who had previously migrated overseas began returning to South Korea after the war, introducing styles and fashion pieces that were previously unheard of in the country."

Modern-day interpretation of Korean period dressing by iconic designer Gee Chun-hee, who founded the brand Miss Gee in 1979.

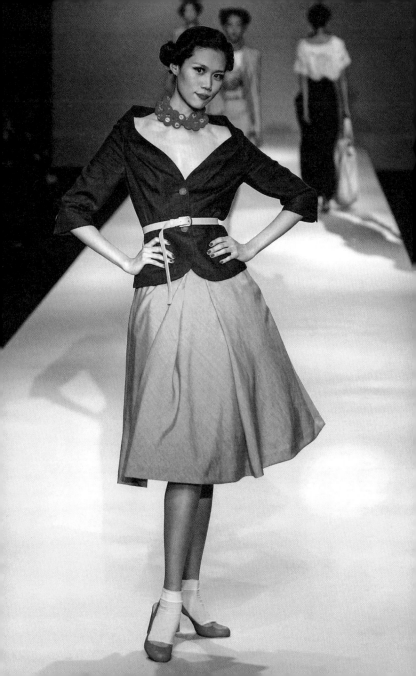

MOTHER OF MODERN KOREAN FASHION: NORA NOH

During an era when arranged marriages and gender role expectations were prevalent in Korea in the early 40s, one determined young woman, Noh Myung-ja, decided to take control of her own fate. From a young age Noh displayed talent in making her own clothes and, at 16, she made a pivotal decision: she changed her name to Nora and embarked on a journey to alter her destiny. Inspired by Henrik Ibsen's play *A Doll's House*, which depicted a housewife named Nora breaking free from societal gender constraints, she divorced her husband and pursued her dream of studying fashion in Los Angeles. This bold step marked the beginning of her vibrant career as a fashion designer, establishing her eponymous brand, Nora Noh, and achieving the distinction of being the first Korean designer to host her own fashion show in 1956.

Throughout the 1950s to the 1970s, Noh dressed numerous high-profile women, creating her signature elegant dresses inspired by the elegance of Korean styles infused with a Western twist. As the first Korean designer to establish her ready-to-wear business in the US market, she introduced Korea to the latest trends from the West, including what was then considered scandalous: the mini-skirt.

Nora popularized the mini-skirt through the famous actress Yoon Bok Hee, designing a bright red form-fitting one-piece dress that boldly cut high on the thigh. In contrast, during this time a military regime in South Korea enforced a

"clothing simplification campaign" with stringent government regulations regarding ways of dressing.

Despite resistance, Noh was unyielding in her vision for women's empowerment through her designs. When asked by a female congresswoman, "Shouldn't women whose legs aren't pretty avoid wearing mini-skirts?" Noh responded assertively: "Should women hide their faces with a veil if their faces aren't pretty?"

Her philosophy was simple yet empowering: "I always wanted women to feel confident in my clothes," she said in an interview with *The Wall Street Journal*. "Once you are comfortable in the clothes you are in, you can move around freely. Then your thoughts are eventually liberated, too." Noh Myung-ja, or Nora Noh, left an indelible mark on Korean fashion history, not only for her innovative designs but also for her determination to challenge societal norms and empower women through fashion.

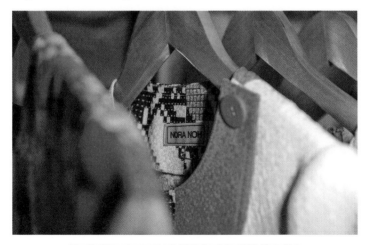

The first brand ever to establish itself, in 1950, Nora Noh is a pioneer in the South Korean fashion industry.

FASHION AS FREEDOM OF EXPRESSION

During the 1970s South Korea underwent a fashion revolution that not only influenced clothing trends but also served as a potent form of resistance against the authoritarian rule of President Park Chung-hee. This era marked a surge of rebellion in the country, with fashion choices becoming a means of expressing defiance.

Inspired by global counterculture movements, men wore clothing and hairstyles that broke the stringent rules, while women boldly sported mini-skirts and low-cut tops, challenging norms and facing police armed with measuring tapes.

Unisex fashion emerged as a profound force in 1970s South Korea, reflecting a generation's rejection of gender stereotypes. Bell-bottoms and flared jeans swept the streets, challenging traditional views of femininity and masculinity. Materials like artificial leather and denim triggered a storm of hot pants, leather boots and trendy jackets that allowed individuals to break free from societal constraints.

Amidst political suppression, a vibrant youth culture blossomed as a collective protest against oppression, utilizing fashion as a tool for self-expression. This shift continued into

Women walking in the streets wearing shorts and colourful pieces, a fashion choice that was considered rogue at that time.

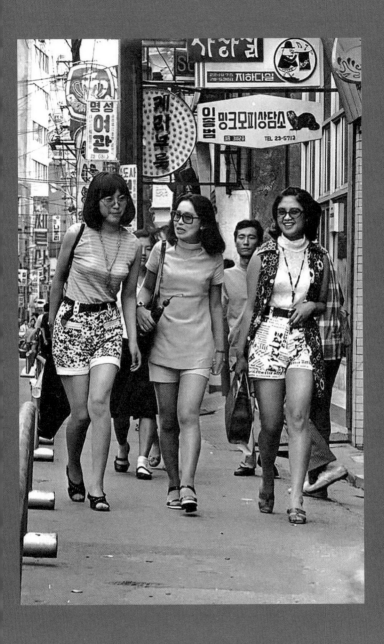

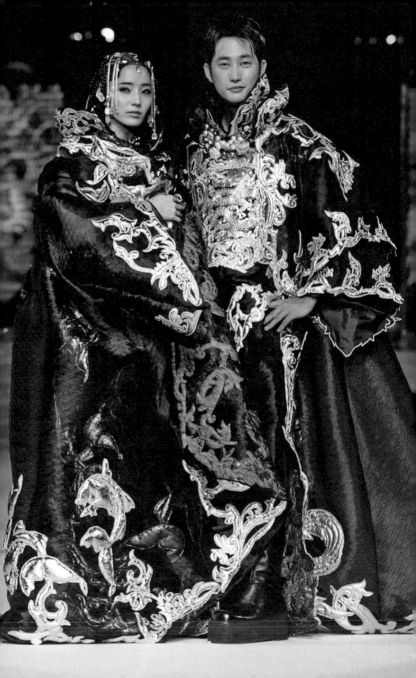

the 1980s, marked by student protests and democratization movements against President Chun Doo Hwan's martial regime. The Gwangju Uprising in 1980 underscored the brutal crackdown on peaceful protestors and resulted in tragic loss.

While political turmoil raged, South Korea's economy gained stability, fostering a flourishing middle class with greater purchasing power. This economic upswing impacted the fashion industry, leading to increased demand for fashion products and altering the market. The changing economic climate not only transformed dressing styles but also the fashion industry itself.

In this evolving fashion scene, André Kim emerged as a pioneer. As a standout pupil of Choi Kyung Ja's Kookje Fashion Design Academy, Kim played a significant role in shaping Korea's fashion reputation. He broke boundaries by becoming Korea's first male designer and expanding his influence to global fashion capitals.

Kim's legacy was marked by incorporating hanbok opulence with futuristic flair. His iconic designs featured rich textures, exaggerated silhouettes and distinct Asian motifs. His dramatic fashion shows, often graced by Korean celebrities, became synonymous with his whimsical and escapist designs.

In the 70s and 80s, South Korea's fashion evolution served as a testament to the nation's resilience and creativity amidst adversity. The era demonstrated that fashion could be a powerful tool for individual expression and societal change, opening the doors for other designers to emulate the fearlessness of those that precede them.

Avant-garde designer André Kim was renowned for his fashion shows' memorable finales, which frequently showcased Korean celebrities as they modeled his iconic creations.

K-POP GENERATIONS AND THE "ORANGE CLAN"

The 1990s was an interesting time for South Korea. In this period, the country was undergoing a significant transformation from a military dictatorship to a more democratic society, culminating in its first democratic presidential election in 1992. It was also the beginning of the country's successful venture as a major exporter of electronics and automobiles worldwide.

In the 90s, South Korea experienced a dynamic fashion revolution fuelled by imports of foreign goods, flooding local department stores with high-fashion and designer brands from Europe. The word "luxury" became a buzzword, signifying the normalization of wearing high-priced items on a daily basis.

Here, the "orange clan" was born in the fashionable Apgujeong neighbourhood. Characterized by the unabashed use and display of high-end luxury brands, the "orange clan" consisted of women who adorned themselves in wool jackets, mini-skirts and leather boots, while the men sported black jeans and sharp dress shoes, with their hair perfectly styled

Korean Fashion Through History

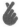

Captured by Korean photographer Kyungil Park in 1999, this magazine cover showcases a model whose vibrant purple hair contrasts with a colour-blocked ensemble.

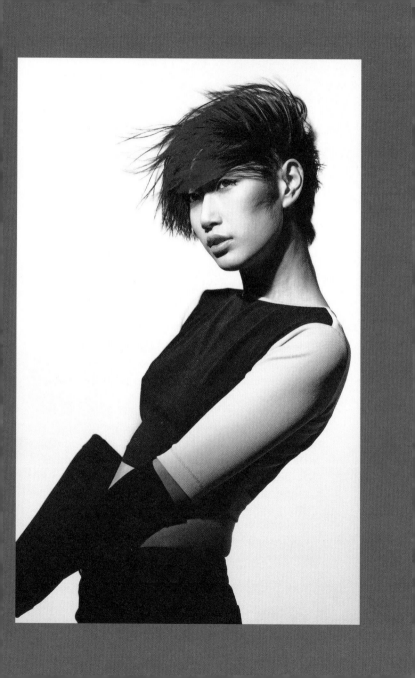

with mousse or gel. They were composed primarily of young, affluent individuals who had the privilege of studying abroad.

Speculations arose about the origin of the term "orange". Some believe it was coined due to the high cost of oranges then, or as a reference to Los Angeles, the city in Orange County, California, USA, where numerous Korean students went to study.

However, the most ground-breaking fashion styles emerged from the influential 90s boy bands, spearheading a new youth movement driven by dedicated fandoms. Among them, Seo Taiji and Boys stood out as trendsetters with their mix of American hip-hop and Korean pop music. Not content with revolutionizing only the music scene, they used fashion to create daring and unprecedented looks in South Korea. The iconic "snowboard look" became a sensation, featuring oversized parkas, dark shades and ski wear worn on the streets, not just the slopes. They also fearlessly combined traditional Korean costumes with elements from other cultures, pushing boundaries and inspiring a generation. This pioneering act, and others including H.O.T., Sechs Kies, S.E.S., and Fin.K.L, ushered in the "First generation of K-pop," opening doors for countless other groups to follow suit.

The androgynous style gained popularity among women, but the baggy jeans, boxy-cut shorts and beanies, worn with cropped tops that revealed the navel, attracted critical looks among the conservative crowd. Alongside these fashion choices, accessories like the saddle and monogram bags, clogs and big belts were paired with even bolder hairstyles in various colours, making a striking statement.

With K-pop's soaring popularity, the public eagerly kept up with their idols' experimental trends, making the 1990s a thrilling and transformative era in South Korean fashion.

During this period the "cyber look" – featuring metallic fabrics and futuristic leather outfits – took the scene. It paved the way for the "Y2K style", which was characterized by maximalism with a retro edge.

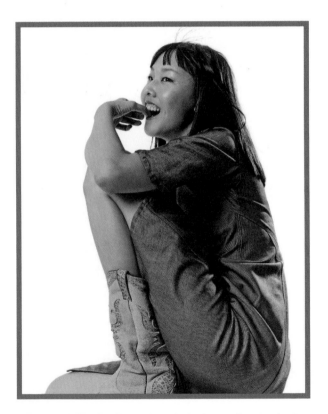

Supermodel Han Hye-jin wearing a denim dress and western boots for *Marie Claire* magazine in the year 2000. (Photo by Kyungil Park)

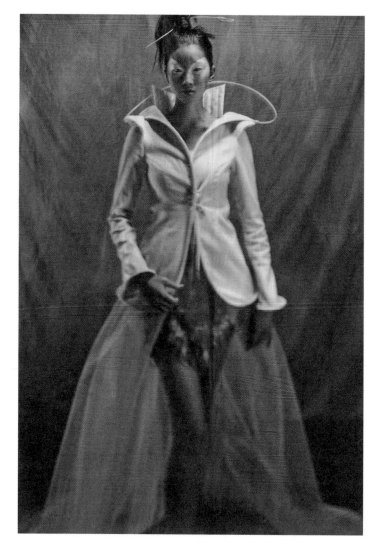

Futuristic editorial themes were prevalent in the late '90s, as depicted in *Seoul* magazine in 1999. (Photo by Kyungil Park)

Monochromatic velour tracksuits, shiny jackets, baby tees, mismatched bright colours and cropped tops became the rage in South Korea, inspired by global pop culture and dotcom technology.

In the mid- to late 2000s, online shopping transformed fashion consumption, making South Korean and Western designer items more accessible. This era also brought the rise of the "athleisure look" as sporty outfits mixed with daily wear became a mainstream sensation.

The runways were witnessing a bolder shift in womenswear, featuring sensual and edgy designs inspired by gothic styles that aimed to empower women to embrace their sexuality. On the menswear front, collections were undergoing a transformation, becoming more refined and diversified, marked by experiments in fit and proportions.

K-pop also reached its peak with the second and third generation of idol groups embracing fresh trends from local and international designers. BIGBANG, arguably one of the biggest Korean hip-hop groups, became trendsetters with their daring and innovative styles. They redefined the norms of K-pop fashion with a mix of sporty streetwear, playful prints, and mixing high-end designer pieces with streetwear staples.

2NE1, a four-member girl group, marked a new era in K-pop fashion, empowering women with fierce and edgy looks blending hip-hop, punk and avant-garde styles. They sported high-fashion designer clothes reformed and restyled to match their eclectic music videos. Veering away from the cute and sexy concepts that were popular in K-pop at that time, 2NE1 sparked the "girl crush" trend that celebrated strong, independent women with bold makeup, experimental silhouettes, vibrant colours and audacious hairstyles –

Sandara Park's iconic "palm tree" hair comes to mind, with a high ponytail resembling the tropical tree.

Like their predecessor BIGBANG, 2NE1 was one of the first K-pop groups to wear high-fashion designer outfits from Chanel, Jeremy Scott, Valentino, Alexander Wang, Balenciaga, to name a few. It was during this time that Western designers recognized the enormous potential and influence of K-pop groups as powerful promoters of their brands. This realization marked the beginning of Korean high-fashion ambassadors.

This era was, without a doubt, an exciting time for Korean designers, whose works are being spotlighted by the popularity of K-pop worldwide. In the next few chapters, an in-depth narrative of some of South Korea's best contemporary fashion designers will uncover the stories behind their most celebrated works, the inspiration that drives their artistic journey, and how K-pop has boosted their brand.

"It was during this time that Western designers recognized the enormous potential and influence of K-pop groups as powerful promoters of their brands."

CL, the charismatic leader of the empowering girl group 2NE1, emerged as the muse for numerous high-fashion brands, forging friendships with acclaimed designers such as Jeremy Scott and Karl Lagerfeld.

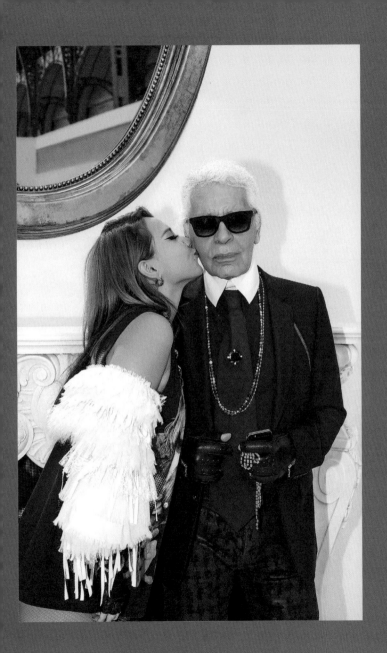

THE KOREAN CULTURE WAVE: HALLYU

FROM KOREAN STARS TO FASHiON iCONS

"Once you overcome the one-inch tall barrier of subtitles, you will be introduced to so many more amazing films," acclaimed Korean director Bong Joon Ho said passionately during his acceptance speech for *Parasite*, a ground-breaking film that made history by winning the Golden Globe award for best foreign-language film.

Aptly named "hallyu", or the "Korean Wave", it encompasses a phenomenal surge of South Korean pop culture that extends far wider than just films. From mesmerizing dramas and thrilling games to captivating webtoons and infectious music, hallyu has transformed into a formidable "soft power". Its cultural influence knows no bounds, with K-content expanding to beauty, fashion and food products from South Korea and hitting $12.45 billion in 2021 thanks to the hallyu craze. According to a report by the newspaper *Korea JoongAng Daily*, exports of K-pop "have grown powerful enough to exceed the combined exports of traditional products like TVs, refrigerators and washing machines," with different genres noticeably taking off on YouTube and Netflix during the pandemic.

"Hallyu started with TV drama series and that was the first level. Second and third level, we watched the success of K-pop in Asia, and Korean food and language have gained popularity along with it. Fourth stage is Korean lifestyle and cosmetics and fashion items that are the biggest spending

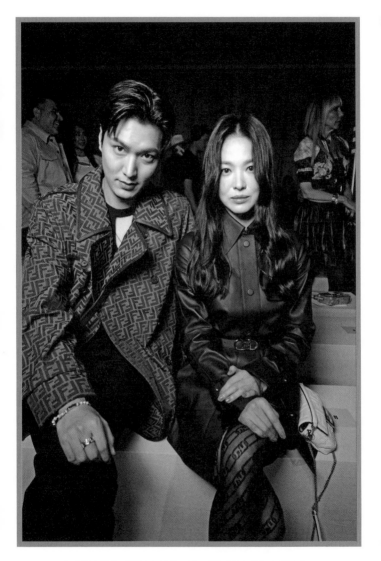

Leading Hallyu K-drama actors Lee Min-ho and Song Hye-kyo
at the Front Row of the Fendi Spring 2023 fashion show.

parts for foreigners," Kim Hyun Tae, CEO of Ra Beauty Core, told *The Korean Times* as he explained the popularity of Korean beauty products propelled by Korean pop culture.

In music, boy band BTS can be credited as the main drivers of hallyu since 2017, by crossing towards the global music market and becoming the first group from South Korea to top the Billboard 200 with their studio album *Love Yourself: Tear*. But their impact went further than chart positions and record sales.

BTS captured the hearts of audiences worldwide with their powerful message of self-love and resilience, transcending language barriers. Their music resonated deeply with diverse groups of fans, touching listeners who may not even understand the Korean language. Their authenticity, genuine passion, and commitment to uplifting their followers earned them a devoted global fanbase, affectionately known as the BTS ARMY.

Another trailblazing group is Blackpink, a four-member girl band who have achieved an impressive collection of 21 Guinness World Records, including the first female K-pop act to reach number 1 on the main British and US album charts, the most-followed musical act on YouTube, with more than 90 million subscribers (and counting), and the most-streamed girl group on Spotify in the world. Their achievements are not just record numbers; they are a testament to their unrivalled impact and influence.

Proving the impact of hallyu, a survey in the 2022 Global Hallyu Trends published by KOFICE (Korean Foundation

K-drama actress Jun Ji-hyun sparked the phenomenon "Jun Ji-hyun effect", which led to a surge in sales for the clothing and accessories she wore in her shows and movies.

for International Cultural Exchange) revealed that nearly two-thirds of respondents (64.2 per cent) said that their perception of Korea changed positively after experiencing hallyu content.

The popularity of hallyu also trickled down to fashion: 29.2 per cent of content consumed by overseas hallyu consumers are fashion brands and items influenced by various Korean genres. K-pop groups, in particular, are deliberately wearing representations of contemporary Korean style through their dazzling costumes in performances and music videos. One of the best examples was the ground-breaking moment when the first K-pop girl group to headline the 2023 Coachella music festival, Blackpink, paid homage to their cultural heritage by showcasing a modern rendition of hanbok traditional dress.

In an interview with the *Korea JoongAng Daily*, Chang Ha-eun, who designed Blackpink's Coachella costumes with hanbok brand Kumdanje, said, "I think there's no other costume that brings out such a diversity of stories and is aesthetically pleasing than hanbok, especially when a Korean singer goes on stage overseas. Hanbok alone showcases the artist's identity, value, pride, heritage and history."

Founder of Kumdanje, Il Soon Lee agreed. "People in the industry have been working for decades to promote hanbok to a global audience. It's so surprising that Blackpink was able to cause a publicity explosion with a single performance that we could not match over the past 30 years."

On the other hand, BTS wore black and gold silk hanboks

Lee Jung-jae, renowned for his role in the popular Netflix series *Squid Game*, served as one of Gucci's ambassadors at the time of this book's publication.

paired with cool sneakers in their music video for *Idol*. As cultural ambassadors of K-pop, BTS frequently incorporate elements of Korean culture in their performances, showcasing the beauty of the hanbok to the world. The style choices made by these two influential K-pop groups have led to the resurgence of global interest in traditional Korean attire.

Hallyu bridged cultures and created meaningful connections through the power of storytelling since the 1990s, long before BTS dominated the scene. K-dramas gained immense popularity outside Korea, first spreading to Asian countries like Japan, China, the Philippines, Thailand and beyond. The stylish outfits and makeup worn by Korean actors and

The globally acclaimed boy band BTS frequently integrate hanbok and traditional Korean elements into their performances, expressing their pride in their Korean heritage.

actresses in the dramas became trends, with fans emulating their ways of dressing and styling. Heartthrobs like Hyun Bin, Lee Min Ho, Kim Soo Hyun, Gong Yoo and Song Joong Ki became international sensations, captivating viewers worldwide. The actresses, too, left a lasting impact, with Song Hye-kyo, Jun Ji-hyun, Son Ye-jin and Shin Min-ah becoming fashion icons as their drama outfits continued to trend in online search engines and sell out long after the episodes aired.

One K-drama that aired in 2013, titled *My Love from the Star*, had a profound impact on the retail industry. The main character, portrayed by Jun Ji-hyun, wore luxury brands like DKNY, Burberry and Celine, and even the makeup brands the actress used sold out almost instantly across Asia due to the series' popularity. This phenomenon was dubbed "The Jun Ji-hyun Effect". The same phenomenon occurred in her subsequent drama, leading to DKNY's China branch expressing gratitude to their Korean counterpart for the rapid sale of a coat she wore.

"South Korea's entrance into the limelight is one of many signals that pop culture is no longer centralized. While today's fashion trends often move at hyper-speed, cultural trends don't move the same. They often have greater longevity and continue to evolve rather than die out completely," Nico Gavino, a culture strategist for Fashion Snoops, a trend forecasting and consumer insights platform, shared in an interview.

One thing's for sure: anything branded with the coveted letter "K" representing "Korean", whether it's music, drama, movie, fashion, or beauty, is set to be a hit.

The Korean Culture Wave: Hallyu

chapter 4

GLOBAL FASHION
AMBASSADORS

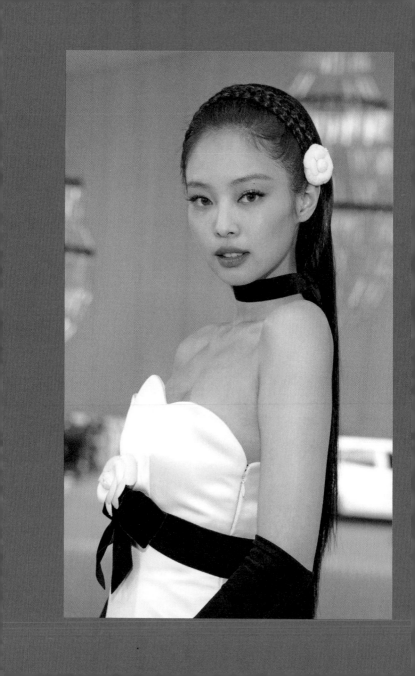

The massive following of K-pop stars is far from coincidental. The buying power of these dedicated fandoms not only enables them to purchase music and merchandize related to their favourite artists but also extends to their favourite stars' lifestyle brand choices. This is substantiated by concrete numbers in sales, brand interest and social media engagements.

One prime example of this phenomenon is the youngest member of BTS, Jungkook, known as the "sold-out king" for his uncanny ability to make items he uses, intentionally or not, sell out off the shelves. For the cover of the August 2020 edition of *Vogue Japan*, the 25-year-old wore Prada's Nylon Gabardine Blouson Jacket, which sold out online in 25 countries, according to reports. Even more fascinating is that Jungkook also causes a shortage of daily items like fabric conditioner, noodle seasoning, books, drinks, among many other items, while doing Instagram live, making him an incredible influencer for both luxury and commercial brands.

Similarly, when Blackpink member Jennie, dubbed "the human Chanel" for her role as the brand's ambassador, shares a designer brand or high-fashion item on her Instagram page, searches for that item immediately surge, resulting in stock shortages. *Rolling Stone* reported that she sold out a lace-up

Jennie, affectionately dubbed "the human Chanel" by her fans, not only represents Chanel but also serves as an ambassador for several other brands, underscoring her significant impact in the world of fashion and beauty.

Global Fashion Ambassadors

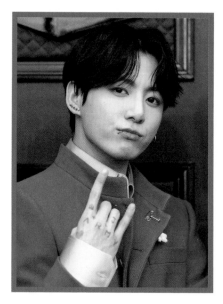

tank top from womenswear brand Cider, leaving the site with only a few sizes left a few days after her post. Likewise, since her bandmate Rosé became the global ambassador for Yves Saint Laurent in 2020, interest in the brand increased by 1,000 per cent in multiple countries within a month of the announcement, according to the *Straits Times*.

Brands are tapping into Korean celebrities for their global influence, driving sales and creating trends. These stars not only resonate with Asian markets but also capture international audiences, making them powerful ambassadors who bridge cultures and redefine luxury in the digital age. They are also known for their impeccable style, which often sets trends and influences fashion choices. Their innate fashion-forward sensibilities make them perfect ambassadors for luxury labels. Moreover, these stars are not just faces: they bring authenticity and genuine passion for the brands

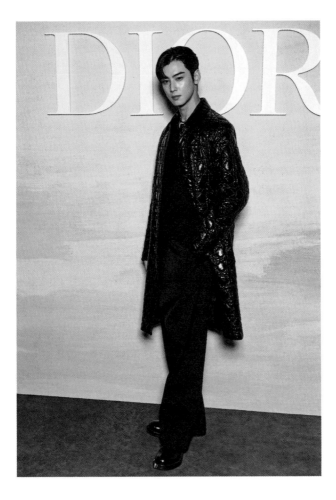

Above: Singer-actor Cha Eun-woo is another sought-after celebrity who represents numerous international and local designer brands.

Left: BTS member Jungkook is widely recognized as "the sold out king", a nickname that reflects his ability to inspire fans to purchase a wide range of products he is seen using, from everyday items to food, accessories and fashion.

they represent. Their charismatic presence and relatable personalities foster a deep connection with consumers.

Bottega Veneta, Louis Vuitton, Valentino, Dior, Celine, Calvin Klein, among many others, enlisted members of BTS as their endorsers. Even early in their debut, the girl group New Jeans secured prestigious deals with fashion and beauty designer brands. High-end jewellery brands are also following suit, with Chopard naming K-pop group aespa as their global ambassadors, while Cartier is represented by Blackpink's Jisoo, Bvlgari by Lisa, Tiffany and Co. by Jimin and Rosé, and Chaumet by Astro's Cha Eun Woo.

Luxury houses are also flocking to Seoul to showcase their collections, with Louis Vuitton presenting its pre-fall collection at the Jamsugyo Bridge because it's a "cultural hub that continues to draw global attention," said chairman and CEO Pietro Beccari in a statement. "I think luxury fashion houses view Seoul as a hip city because of its youthful and energetic atmosphere," Kyoung Eun Rhee, a former fashion editor at *Elle* magazine and a stylist to young Korean actors, told *Time*. Likewise, Gucci chose the iconic location of Gyeongbokgung Palace in Seoul as the backdrop for its 2024 Cruise show, emphasizing the intertwining of Italian and Korean culture and heritage at the event.

Korean celebrities' wholesome image, innate style and humble personalities have a universal appeal, transcending nationality. Their relatability makes luxury brands more accessible, bridging the gap between aspiration and reality. It's not just about their nationality: it's about their authenticity, which renders luxury an achievable dream for a broader audience.

Lisa was appointed as the global brand ambassador for the prestigious jewelry brand Bvlgari, joining notable figures such as actresses Zendaya, Anne Hathaway and Priyanka Chopra.

chapter 5

CONTEMPORARY KOREAN DESIGNERS

DESIGN MASTER: LIE SANG-BONG

South Korea is often known for its young, vibrant and trendy scene, with street style dominating the sartorial aesthetic of the fashion-savvy youth, the huge significance of which will be discussed later in this book. But certainly this is only one side of commercial fashion in Korea, and on the other, its more established couture houses, tell a completely different story.

Enter one of Korea's fashion greats that elevated high fashion and artistry in the country, Lie Sang-bong, who shares the Kookje Fashion Design Academy lineage with André Kim. Like Kim, he expanded Korean fashion overseas, with collections influenced by various forms of Korean culture, such as traditional paintings, hangul (Korean alphabet and calligraphy) and architecture. With extensive experience in fashion for over 20 years, he aims to make beautiful pieces that emphasize reviving craftsmanship, in terms of materials and techniques, from embroidery and patterns to colour dying. Some of his most famous works featured Korean folk paintings that depict the glorious and everyday lives of people from the past, as well as the *dancheong*, a Korean painting technique applied on artifacts, musical instruments and temples.

In an interview with the *Seoul Journal*, Lie explained, "Being a Korean designer is not just duplicating Korean-inspired designs from the past. It is all about creating something old and traditional while applying elements for the modern age." In this line-up, we spotlight other established icons and emerging talents who skillfully integrate traditional influences with innovative techniques, each contributing to Korea's distinct creative voice.

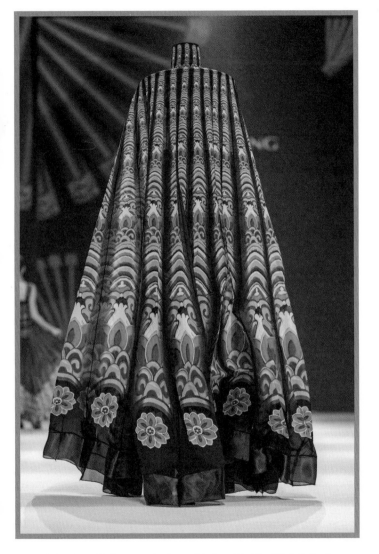

A look from Lie Sangbong's show at the Seoul Fashion Week Spring/ Summer '24 features *dancheong*, a traditional Korean painting technique.

Contemporary Korean Designers

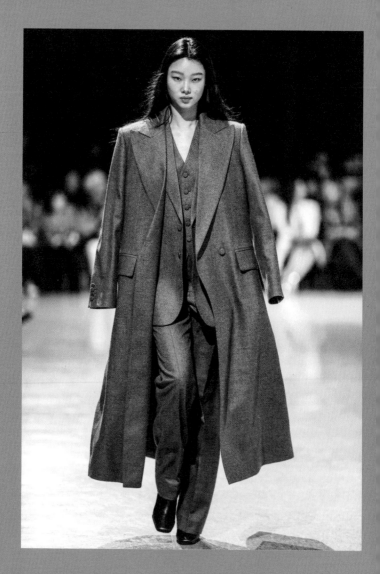

A glance at Kim Seo-ryong's Spring/Summer '24 collection, showcasing an all-grey ensemble that challenges traditional suit norms.

THE SLEEK TAILORED SUIT: KIM SEO RYONG

When it comes to fashion shows, menswear designer Kim Seo-ryong knows how to put on a show. He takes his collections outside the confines of Seoul Fashion Week's catwalks, a stage he's graced since 2001, instead, choosing unconventional venues to breathe life into his collections. Among these locations was Seoul's Olympic Park tennis stadium, where models showcased breezy Spring/Summer '20 suits. Another striking show took place in a revived oil tank in the outskirts of Seoul.

"I want to have fun, and show that there are many different ways to display apparel," he said in an interview with the *Korea Herald*. "Guests take the time out of their busy schedule to attend the fashion show. And I think it's important for them to relish the show and have fun together." In the past, he's chosen a *makgeolli* (traditional Korean rice wine) bar, an art gallery and also a sports arena for his presentations. As the leisurely ambience and relaxed mood that his chosen spaces emanate, so does the ease and fluidity of his tailored suits.

Deviating from the traditional matching jacket-and-pants formula, Kim Seo-ryong gives his pieces a more unexpected twist, just like his shows. Since the beginning of his career, he has experimented with fabrics, which he often chooses to make from scratch. "I make my own textiles through creating special prints, trying out different colour combinations or dyes," he shares. "This is the only way to keep my designs original and authentic."

There's always an element of surprise when it comes to the outcome of his work: from bold styles like floral suits, zebra prints, tie dye, sequined sets, to more toned-down offerings like oversized neutrals, sharkskin grey combinations, to all-black leather. Perhaps his sense of colour and unique patterns stem from his background as a painter, having majored in fine arts before discovering his passion for fashion design. "Although I think the material and tailoring are important, I hold a distinct perspective on colours," he says. "As a person who draws and paints, I get inspired by spontaneous moments in everyday life and my surroundings."

As a first-generation Korean men's clothing designer with more than 30 years of experience, he has become the go-to choice of famous Korean celebrities when it comes to representing Korea on the global stage. He dressed Psy in the iconic "Gangnam Style" music video and performances, and boy band BTS for the official South Korea tourism campaign, "Your Seoul Goes On". His eponymous brand has been embraced by, among others, actors Kim Soo-hyun, Lee Min-ho and Lim Si-wan, Cha Eun-woo.

Whether he's creating for top stars or for the local market, one thing prevails. Each piece is made with meticulous tailoring and exquisite taste that can only come from a man who has seen it all – trends rising and waning, new faces emerging, and the revivals that come in the unpredictable world of fashion. He has proven that suits don't always have to be stiff and outdated; they can be cool too.

Reflecting on the huge interest of the international market in Korean fashion, he shares, "I want to let people know that there are high-quality men's clothes with a clear identity in Korea, as well. It's always an honour and fun to see many people wearing apparel with my label."

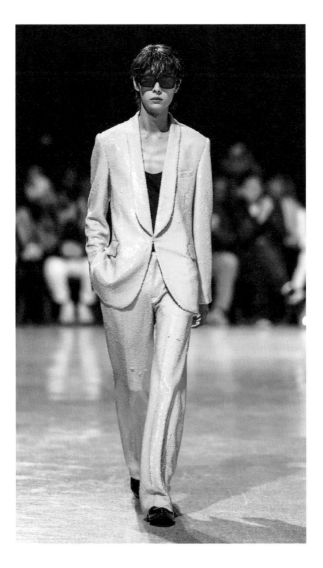

One of the designer's signature styles is a
sequined suit in various colours.

A striking look from "Sailing Stripes",
one of Kimhēkim's conceptual collections.

PLAYFUL MiNiMALiSM: KiMHĒKiM

Beyond aesthetics, fashion often provokes, shocks and initiates dialogues with its audience. Designer Kimhēkim exemplified this in his Spring/Summer '20 show when a model walked the runway with an IV drip – a bold statement that became viral on social media. Yet, for Kimhēkim, this was more than a "stunt": it symbolized support and aid, marking a pivotal moment in his career.

However, the brand's global recognition isn't solely reliant on shock value; its remarkable creations speak for themselves. Kiminte Kimhēkim's journey parallels that of many budding designers who rejuvenate the fashion scene. After refining his skills at ESMOD Seoul, he expanded his horizons at ESMOD Paris and Studio Berçot, calling Paris his second home. Interning under Nicolas Ghesquière at Balenciaga solidified his foundation.

His inspirations are as diverse as they are thought-provoking. The "Obsessions" series showcases his audacious exploration of various conceptual themes – ranging from materials like "Denim Love", to key style elements such as "Rose & Cuir", "Bow Universe", "Sailing Stripes", and even ruminations on loneliness, self-love and gender fluidity translated through design. One, titled "Hair Chronicles", draws from discarded wigs found at a wig store.

Although Paris-based, Kimhēkim remains deeply tied to Korea, his name hailing from the ancient Gimhae (sometimes spelled Kimhae) Kim clan of South Gyeongsang Province. This lineage, renowned for crafting jewellery and accoutrements like golden crowns and ceramics during the Goryeo dynasty, fuels his creative spirit. "I'm very proud to have inherited this family name. Eventually, as the Kimhēkims did long ago in history, I also would like to foster a community of creativity and artisanship."

His grandmother taught him traditional Korean sewing, igniting his interest in designing. "My Korean identity has always been a part of who I am and how I design," he says. His love for his Korean roots run deep. "I'm still learning Korean traditional decorative techniques at the Korean Cultural Center. These experiences further inspire creation. For FW23, I obsessed over traditional Korean knotting methods, weaving them into clothes and accessories."

His creations, though minimalist at heart, feature bigger-than-life elements. An oversized suit dress adorned with a headdress with hundreds of strings of pearls, a voluminous organza skirt inspired by the hanbok skirt, and a corset shaped by braided hair – are only a few examples of this.

Finally, when asked about his thoughts on the rise of Korean fashion, he candidly says, "Isn't it time for Korea to take its turn? The government's prolonged investment in arts and culture, dating back to the 90s, seems to bear fruit. Young Koreans venturing abroad for cultural exploration amplify the trend. This youthful and vibrant synergy creates an interesting result that amplifies the current trend. I also lived in Paris for over 10 years, and I love infusing the two cultures together in my work."

Kimhēkim is often inspired by the hanbok and frequently incorporates design elements and textiles used in making the traditional attire

ROMANTIC REBEL: BMUET(TE)

From the vibrant streets of Seoul, punk's irreverent spirit resonates deeply. Seoul's youth seamlessly blend elements of glam rock, unconventional tailoring and edgy accessories, crafting an aesthetic that challenges norms. Plaids, statement pieces and deconstructed ensembles merge with hints of casual streetwear and a new defiant attitude. BMUET(TE) seamlessly infuses Korea's love for streetwear and casual fashion with punk styles to meld rebellion and everyday comfort. The result is a unique bold statement with laid-back cool, capturing a distinctive style that's both edgy and approachable.

Contemporary Korean Designers

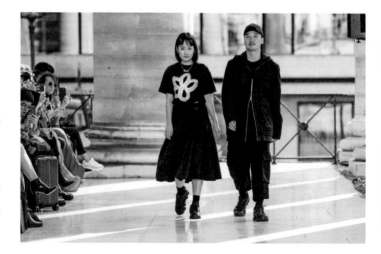

BMUET(TE) designers Jina Um and Byungmun Seo at the K-Collection Womenswear Spring/Summer '20 show as part of Paris Fashion Week.

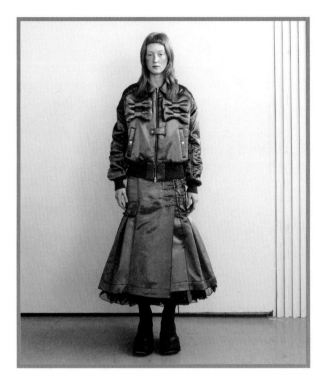

A look from the Autumn/Winter '23 collection of the brand features a military-inspired jacket made feminine with a bows and a touch of lace.

Established in 2017, brand BMUET(TE) helmed by design duo Byungmun Seo and Jina Um, offers a fresh take on the iconic styles of punk revolution with its androgynous looks, bold silhouette and deconstructed uniforms. The brand debuted its Spring/ Summer 2022 collection with much buzz in London Fashion Week, unveiling its concept, "Surplus Reality", which expresses its fashion iterations of "deviance that escapes our daily ways of experiencing reality and reinterprets it from a rather unfamiliar point of view."

"I envision women and men who exude freedom and rebellion, untouched by societal or cultural constraints," Seo explains. Playing with volume, layering and structure, the brand embodies a vintage meets contemporary street style, with inspirations drawn from "old magazines, vintage photo books, and the style of people in everyday life."

Embracing Korea's penchant for incorporating vintage elements into ensembles, BMUET(TE) swiftly ascended to become the go-to designer for Korean stars. The iconic ribbon-detailed top, donned by Blackpink's Jennie during her "You and Me" stage performance, was also embraced by solo artist Taeyeon. Several popular K-pop girl groups like IVE, Nmixx, StayC and MAMAMOO have worn pieces from BMUET(TE), personifying sophisticated, strong and independent young women who blend delicate aesthetics with an edge.

It wasn't long before the international stage beckoned with keen interest in the brand's avant-garde allure. Some of its most memorable overseas projects include costume production for the Hollywood movie, *The Hunger Games Mockingjay*. Abroad the duo showcased their signature styles in eminent fashion shows spanning Florence, Paris and London.

BMUET(TE) stands as a dynamic testament to the fusion of punk spirit and innovative design, bridging Korea and the world. "We have been inspired by eastern avant-garde silhouettes through traditional Korean clothing. We would like to introduce it as a great brand that is romantic, free and rebellious," they said.

BMUET(TE)'s creations combine romantic themes with rebellion, using pieces that play with volume and deconstruction.

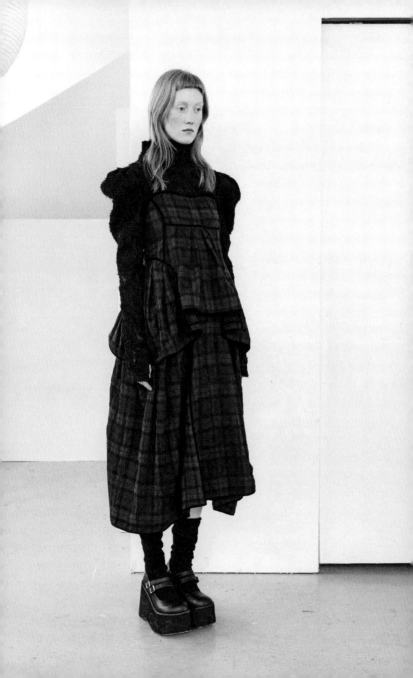

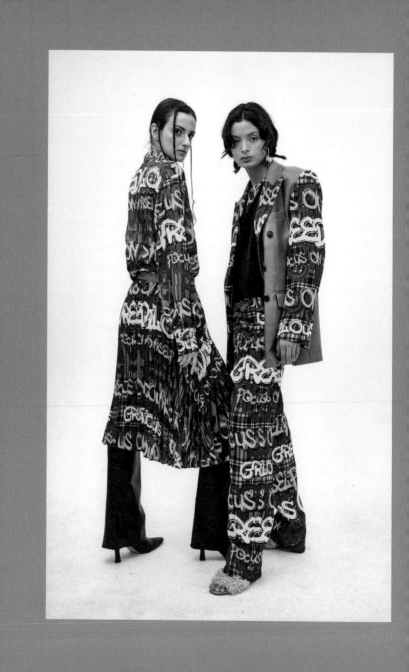

GRAPHIC PRINTS: GREEDILOUS

Watching the Greedilous catwalk show collection is like playing with a kaleidoscope toy – the clothes' symmetrical patterns and geometric digital prints will leave you transfixed. This reflects designer Younhee Park's preference for infusing surrealistic, computer-generated digital prints with classic silhouettes that mirror her risk-taking spirit.

The designer's flair for dramatic aesthetics and abundant decalcomania prints solidified her brand's identity, resonating not only in Korea but also at the Paris and New York fashion weeks. "Being a designer representing my country in New York and Paris was an honour, introducing Korean fashion to a global audience," Park says.

Her signature geometrical prints, vibrant hues and laidback silhouettes that have become recognized all over the world were products of Park's creative imagination and her extensive background experience. With a foundation in industrial design, she transitioned to fashion, infusing her creations with a mastery of shapes, balance and vivid colours that radiate positivity. From galaxy-print padded jackets to pop culture-inspired colourful sets, the brand's offerings push boundaries. The street art-inspired casualwear echoes urban vibrancy, while the designs continue to transcend conventions, crafting a fashion narrative that's both bold and diverse. Park was dubbed "The Queen of Print" by the Press.

Greedilous is known for its signature looks, which often include vibrant pieces adorned with the brand's logo.

Contemporary Korean Designers

Greedilous, at the forefront of merging fashion with technology, partnered with LG's Metaverse AI Tilda for its Autumn/Winter '22 New York collection. This trailblazing collaboration brought AI sensibilities to the fashion realm and sparked a global conversation. As Greedilous explores the intersection of AI and fashion, it unveils a new chapter in its journey, venturing into e-commerce markets through NFT and strategic brand expansions.

An interesting quality of Park's body of work is its ability to become both wearable and aspirational. Greedilous ensembles grace top K-pop idols, global celebrities (Beyoncé was spotted in the brand's leather jacket and printed shirt dress), and at the same time people on the streets. The label beckons those who seek to make a statement, transcending conventional attire – welcoming anyone to embody the spirit of a Greedilous individual challenging the confines of everyday fashion.

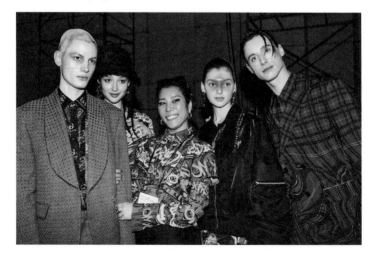

Known as the "Queen of Print", designer Younhee Park joins models backstage at her Autumn/Winter '23 show.

FEMININE EDGE: HANNAH SHIN

Amidst the prevalence of romantic feminine couture styles in Europe, which emphasize delicate fabrics, lace, bows and graceful silhouettes, South Korea's fashion scene takes a different route. With a preference for practical urban uniforms like streetwear and athleisure, the trend-savvy and active youth diverge from the intricate and dressy styles. In this context designer Hannah Shin's brand stands out by its reintroduction of modern romantic sophistication, blending feminine elegance with contemporary elements inspired by Seoul's high-tech atmosphere and Western artistic influences. Sustainability is also woven into every stitch of the brand's creations.

Her predilection for dramatic elements, grandeur and dynamism make sense since the designer is a fan of traditional art. "I like to reinterpret it as an experimental genre of contemporary art. It is always interesting to apply new technologies in the field of science and technology into fashion," she says. "As a female designer, I get design inspirations from the lives, values and philosophical messages of women who caused a sensation in their time."

Take for instance some of her looks from the Autumn/Winter '23 collection, dubbed "Light Space": a draped tulle dress encased within a hard cage skirt, a balloon mini dress with contrasting textiles that feature 3D diamond shapes, and a moto jacket with billowing sleeves paired with silver leggings. Her Spring/Summer '24 collection titled "Future Terrain" maintains the futuristic motif of her previous collection, using objects and imagery found in the universe, such as meteorites, auroras, rocks and the like, as inspirations. The designer

explains, "Just as the past and future that seem to be separated from each other are connected within the same space, this collection aims to show a changing pattern of the connection and fusion of disparate materials within one outfit."

Shin's Korean roots play a pivotal role in her design philosophy. The brand's ethos lies in harmoniously blending traditional values with new cultures, crossing borders and times. She says, "I don't believe many countries have grown as swiftly as Korea, nor do I see many nations striving to preserve traditions as we do. It's a core principle for our brand to seamlessly unite new culture and technology with tradition. This, I believe, is the path to achieving the utmost global beauty as a Korean designer."

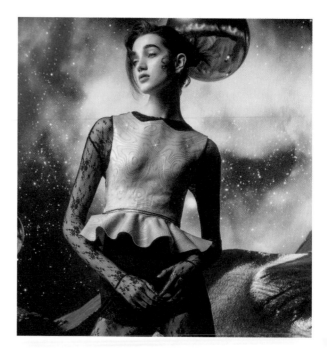

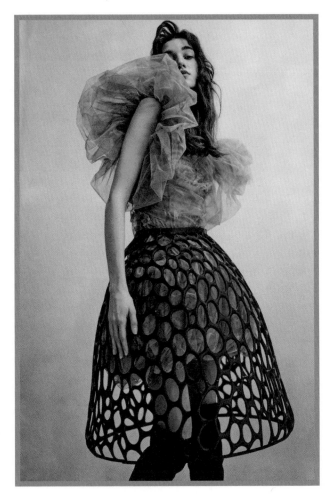

Above: A striking look from Hannah Shin's "Light Space" collection, featuring a draped tulle dress encased with a hard cage skirt.

Opposite: The brand continues taking its inspiration from elements of the universe, with its otherworldly take on modern dressing. (Photo by Choi Song 3D graphic artist Hyun Ho Park)

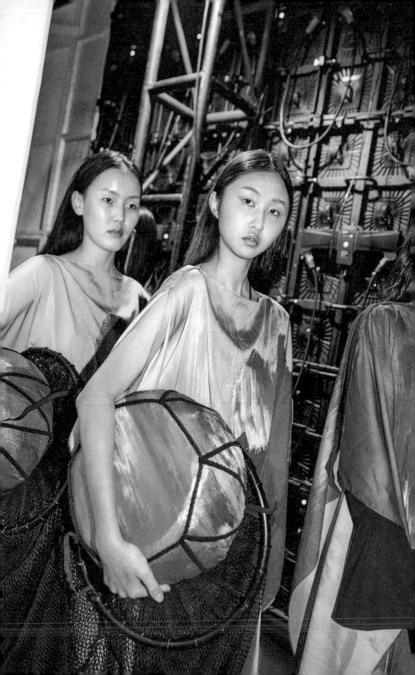

REVITALIZING CULTURE: PALE TURQUOISE

Jeju, South Korea's largest island, embodies the nation's vibrant culture and a storied tradition of ocean-inspired innovation. With a deep connection to the sea, Jeju's essence is entwined with its waters, influencing its economy, spirituality and daily existence. This island haven is a testament to the profound impact of the ocean on every facet of life, fostering a rich history of creativity and resilience.

Once the cornerstone of Jeju Island's economy, fishing was a male-dominated domain until the emergence of the *haenyeo*, the female divers who braved the waters to provide sustenance for their families. Enduring six to seven hours of daily dives to gather seaweed, shellfish and seafood, these divers stand as pioneering figures of female empowerment in Korea. Their resilience, vigour and relentless work ethic characterise them as Jeju's invaluable treasures, earning them the title "mothers of the sea".

In 2016, UNESCO acknowledged the divers' legacy as Intangible Cultural Heritage, so immortalizing their history. However, their way of life faces decline as ageing *haenyeo* struggle to find successors due to the occupation's inherent dangers. Lyn Jun Park, a Jeju native and fashion designer, strives to rekindle appreciation for the divers and seeks inspiration from their lives. He established his fashion brand, Pale Turquoise, to illuminate the island's allure and enigmatic

Designer Lyn Jun Park draws his primary inspiration from his home of Jeju Island, infusing his designs with the island's colours and aquatic elements.

Contemporary Korean Designers

charm. Just as he uses fashion to breathe life into the waning *haenyeo* tradition, he protects the ocean through zero-waste and eco-friendly design practices.

"Ten years after becoming a designer, I have learned that designers have the power to change industries, inspire countries and move the world," Park says. "I wanted to reflect Jeju through fashion with aesthetics learned from the old to make new."

Deriving from the distinct blue and green colours of the ocean, he named the brand Pale Turquoise, with sea creatures and elements like turtle shells, corals, fish scales, the sun and waves as his main motifs. From sea-inspired colours, resort- and swimwear to upcycled accessories like shell-inspired bags and phone cases, each piece echoes the island's tranquillity and maritime heritage.

To preserve Jeju's *haenyeo* culture, he founded the Haenyeo Clothing Research Institute, crafting top-notch Korean diving suits for the *haenyeo* divers and contemporary options for the public. "I think it's better that they wear suits made locally, with a goal to create better and more practical suits to protect them while diving for more than seven hours."

Nowadays, his interest has expanded to Haesinje (Religious Ceremony to the God of Sea) and Korean shamanism. "I am interpreting it traditionally rather than taking a religious approach," he shares.

With his continued efforts to preserve the legacy of the *haenyeo* and promote tourism in his home through fashion and exhibitions, Park received a Global Influencer Award at the 2023 UN International Youth Day. He says, "Fashion isn't just transient fast fashion; it's an expression of history and era. As I design, I envision these garments becoming tomorrow's history. My aim is to craft functional yet meaningful clothing."

The designer is recognized for his contributions to preserving the culture of the *haenyeo*, the women divers of Jeju. His objective is to offer high-quality, locally-produced suits for these divers.

In 2015 fashion editor Bethan Holt predicted in *Grazia* magazine that Korean fashion would be "The Next Big Thing" and that it was "time to get serious about Korean fashion." She wrote further, "From a fashion perspective, it seems like the talent emerging from Korea is also anticipating how we'll be dressing into the future."

Yet this insight arrived after years of Korean fashion striving to make its mark. Since the early 1990s, South Korea's official agency that promotes culture, sports and tourism (now known as Korea Creative Content Agency or KOCCA) has been investing in programmes to incubate local talent, providing funds and mentorship opportunities to grow the Korean fashion industry. However, emerging designs lacked a spotlight. To address this, the Seoul Metropolitan Government, in collaboration with the Seoul Design Foundation, established Seoul Fashion Week (SFW) in 2000.

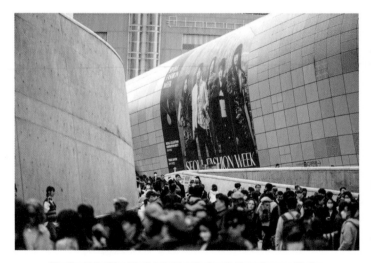

Seoul Fashion Week

The Seoul Fashion Week is held at the iconic Dongdaemun Design Plaza, or DDP, an arts and media complex in Seoul.

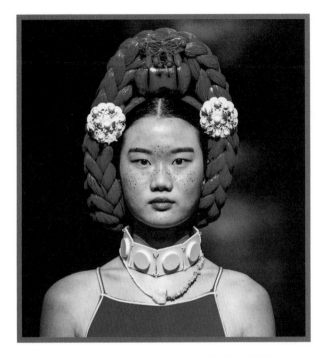

A look from the brand NOT ENOF WORDS/DEARLIFE
which features a Korean traditional hairstyle typically
worn by members of royalty in the Joseon dynasty.

Before it became known as SFW, fashion shows first kicked
off in 1987 and were simply known as "local festivals" that did
little to attract a big audience, much less international buyers.
For decades the Korean fashion industry struggled financially,
and in 2004 authorities even pondered disbanding the fashion
organizations that put them together.

Korean designer Jung Ku-ho was appointed as the first
designer to be appointed as general director of SFW in 2015,
and he had the herculean task of putting Korean fashion on

the international map. Under his leadership, he initiated 10 Soul, a project that aimed to discover 10 young creative designers whose brands would be marketed globally and be offered as a platform that was accessible to international buyers and global fashion experts. "In the past, when I met fashion experts overseas, very few knew about Korean designers. But now they know almost all Korean designers, which surprised me," Jung told the *Korean Times*.

It's undeniable that hallyu has played a big role in the expansion of Korean fashion overseas. The fusion of K-pop and the digital era has created a new platform for Korean designers to attract international buyers. According to Jung, Korean fashion is benefiting from K-pop. "They are curious about Korean celebrities' fashion styles and the skincare products they are using. Some experts ask me if they can partner with certain Korean singers when we discuss collaboration shows. The success of Korean music has sparked global interest in Korean content, including fashion.

"In the digital era, I think designers no longer need to look to the Big Four fashion shows for their global expansion. I personally believe showcasing their works at Seoul Fashion Week is enough," he said. "Thanks to the internet, we know what's happening on the other side of the globe even though we're not there. Likewise, we can see global designers' shows here. We provide live streaming services during Seoul Fashion Week and people living on the other side of the globe can watch all runway shows in real time."

In the following few years, SFW's objective changed from introducing Korean designers to the world to turning the buzz into championing more local products and maintaining a sustainable, profitable business. Collaborations with non-fashion Korean brands and sponsored shows have become more common, and the "see-now-buy-now" system that

fashion weeks in the West have begun to adopt is also being initiated in SFW through trade shows and buyer exhibitions. Korean fashion has also been opened wider to the public, unlike before where only a privileged few could attend.

To expand Seoul Fashion Week's reach, the organizers required an iconic, spacious venue. Initial presentations occurred in makeshift tents near a mall or at hotel convention halls, but the environment didn't align with the desired cool, youthful vibe of the capital city. Then, in 2013, the ambitious Dongdaemun Design Plaza (DDP) project concluded. Conceived by architectural luminaries Zaha Hadid and Samoo, known globally for their pioneering, deconstructivist designs, DDP stands as a neo-futuristic masterpiece nestled in Seoul's

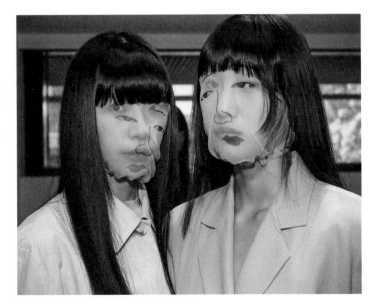

Models wearing graphic masks similar to traditional Korean paintings at the LIE Spring/Summer '21 collection.

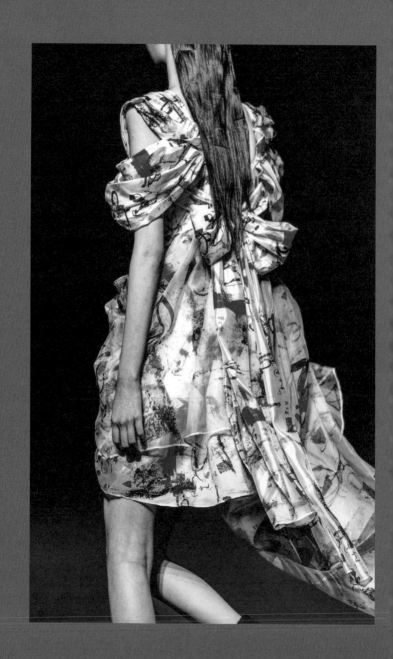

Dongdaemun district. Distinguished by dynamic curves, bold structures and a greyscale palette, DDP embodies South Korea's progressive facet.

The edifice encompasses an array of public areas dedicated to exhibiting art and design: an exhibition hall, design museum, media centre, design market and Dongdaemun History and Culture Park. The art hall serves as a versatile space for conventions, trade expos, exhibitions, fashion presentations, concerts and performances. Given Dongdaemun's status as Korea's biggest wholesale and retail shopping district, relocating Seoul Fashion Week to DDP made perfect sense – enabling global attendees to congregate within this spectacular space.

For the first time in Seoul Fashion Week's history, young Seoulites and fashion enthusiasts worldwide converged at DDP in 2014, donning vibrant hairstyles and eclectic ensembles that boldly expressed their individuality. The ramp, usually leading to the building's futuristic design, transformed into a runway. Every March and October – the most anticipated months on the Korean fashion calendar – witnessed this spectacle, dedicated to unveiling the upcoming Spring/Summer and Autumn/Winter trends.

DDP's metallic greys came alive with an array of regional and international attendees, who represented diverse crowds: the logo-obsessed hypebeasts, lovers of psychedelic hues, urban classics, flamboyant cliques, trend-focused youth and every style in between. What sets this phenomenon apart from other fashion weeks is that only a fraction of this immense gathering consists of actual showgoers. The formerly

An ensemble by BIG PARK, resembling a painted canvas, graces the runway at Seoul Fashion Week Spring/ Summer '24 with its artfully draped design.

exclusive nature of fashion shows has evolved into an open community gathering for fashion enthusiasts. It's a big festival of sorts: rows of booths featuring Korean fashion, magazines and beauty brands adorned the surroundings. Large screens broadcasted real-time catwalk events, enabling spectators to stay updated on the latest trends.

Street styles embraced by the masses often become the defining factors of upcoming trends. While similar dynamics exist globally, South Korea's scene takes the spotlight, where local styles shape the narrative.

The strong street style culture in Seoul has attracted photographers from around the globe, drawn by the allure of distinctive fashion. Jay Lim, a Korean street style photographer with 12 years' experience, offers insight into the uniqueness of Korean street style. "It's the fusion of high and low brands, designer and commercial – it's the ability of Koreans in styling everything together," he remarks. Reflecting on the impact of hallyu, he recalls covering events at the New York, London, Milan and Paris fashion weeks, capturing Korean celebrities attending designer shows. "The global surge in Korean culture through music, dramas and social media ignited the Korean wave. I often see the big impact of Korean celebrities whenever they attend shows in Europe, where fans eagerly wait to have a glimpse and take selfies with them."

During the late 2010s, a number of homegrown Korean brands gained prominence and established themselves as regular fixtures at Seoul Fashion Week. These included Song Zio, Beyond Closet, Kwak Hyun Joo, Push Button, Resurrection and Miss Gee, KYE and others.

Caruso, crafted by designer Jang Kwang Hyo, stands out as a brand celebrated for its distinctive fusion of sleek contemporary menswear with timeless traditional elements.

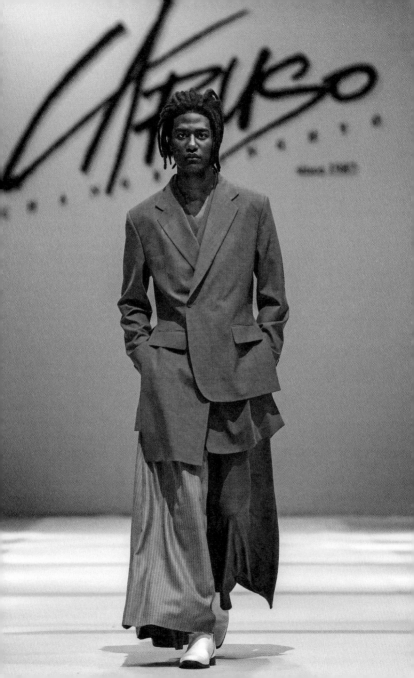

In contrast to the couture and avant-garde designs prevalent in the West, Korea stands out with its focus on wearable and commercial fashion. What sets Korean fashion apart is its infusion of traditional design elements into street style, creating a unique and captivating aesthetic. Take, for example, the brand NOT ENOF WORDS/DEARLIFE, which showcased its Autumn 2023 collection featuring modern looks adorned with traditional robes, headpieces and hanbok-inspired details. Additionally, menswear brand Caruso modernized royal garments and infused motifs on Korean spirituality in their Spring/Summer '22 collection, which took the runway by storm against the stunning backdrop of Changdeokgung Palace in Seoul. This shows how important it is for Korean

Above: Kwak Hyun Joo, a designer brand, is acclaimed for its quirky, whimsical and vibrant creations inspired by pop culture.

Opposite: Caught backstage at the ULKIN show, where avant-garde deconstructed and sustainable designs take centre stage, a model prepares to grace the runway.

Seoul Fashion Week

designers to weave their cultural heritage into their modern designs, to showcase a stylish ode to their roots.

In Seoul Fashion Week, the spotlight wasn't limited to designers alone; models who dominated the catwalks, such as Lee Sung-kyung, Jang Ki-yong, Nam Joo-hyuk and Kim Woo-bin, would later rise to fame as prominent K-drama actors. This symbiotic relationship between fashion, K-pop and K-drama highlights the inseparable connection that defines the contemporary cultural landscape of Korea.

This fashion event stands as a resounding testament to the remarkable synergy between Korean talent and global fashion enthusiasts. The event's journey, from humble beginnings to its iconic status, mirrors the evolution of Korea's fashion industry. Korean designers flourish under the spotlight as do the diverse crowd of stylish attendees converging at DDP, indicating fashion's universal language that transcends borders. As the runways and streets intertwine at this dynamic event, Seoul Fashion Week unites the world's fashion aficionados, fostering a cultural exchange that celebrates both individuality and collective style.

"In contrast to the couture and avant-garde designs prevalent in the West, Korea stands out with its focus on wearable and commercial fashion."

Oftentimes, the catwalk becomes a launchpad for models to transition into K-drama stardom. Model-turned actress Lee Sung-kyung graces the Beyond Closet show.

chapter 7

STREET-STYLE TRENDS

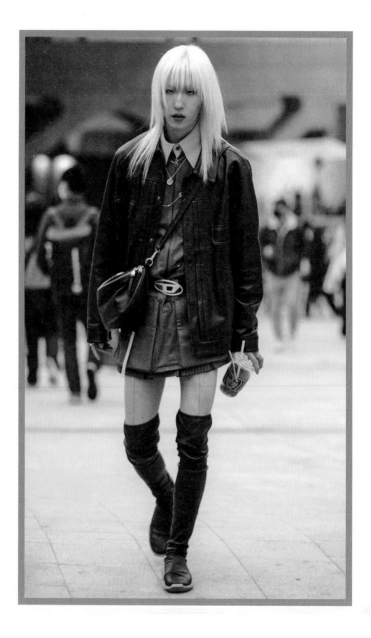

FASHION INDIVIDUALITY IN SEOUL

With fashion shows inside the DDP setting the stage for thrilling action, the atmosphere outside echoes with a different kind of buzz, captivating the fashion crowds. Seoul Fashion Week has experienced remarkable growth in attendees and spectators since its inception, giving rise to an array of styles that add to the vibrant tapestry of this fashion event. Amidst the diversity, certain looks consistently emerge, defining the unforgettable Seoul Fashion Week experience.

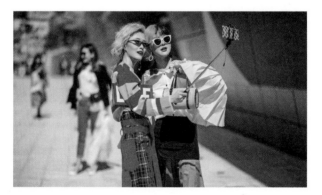

Above: Popular fashion influencers in their bright ensembles take selfies at Seoul Fashion Week.

Opposite: Androgynous and genderless fashion takes centre stage in street styles. (Photo by Jay Lim)

Trends that take centre stage are street style and genderless fashion, which effortlessly blend masculine and feminine elements through various iterations of suit dressing and androgynous sporty ensembles. Subcultures that may usually hide amidst Korea's conservative nature, such as punk, body modifications and tattoo artistry, fearlessly use fashion as a canvas to boldly express their individualities, showcasing the transformative power of SFW. Additionally, the event brims with couple dressing and twinning looks, as friends and lovers seize the opportunity to celebrate their bonds through fashion statements that radiate connection.

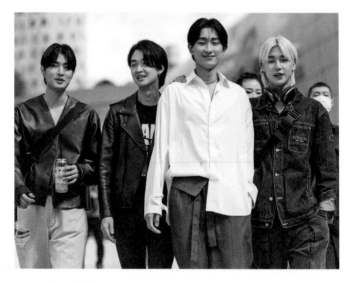

Above: Stylish camaraderie on display as a group of young men showcase their coordinated fashion at Seoul Fashion Week, eagerly posing for the lenses of street photographers.

Opposite: Effortless chic defines a model's off-duty appearance, clad in a sleek head-to-toe black ensemble complemented by a striking red hair colour. (Photo by Jay Lim)

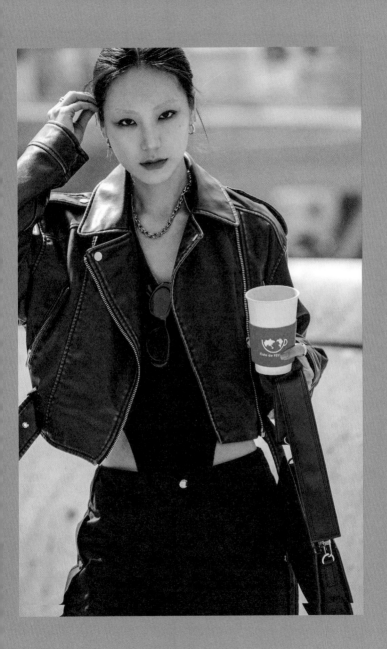

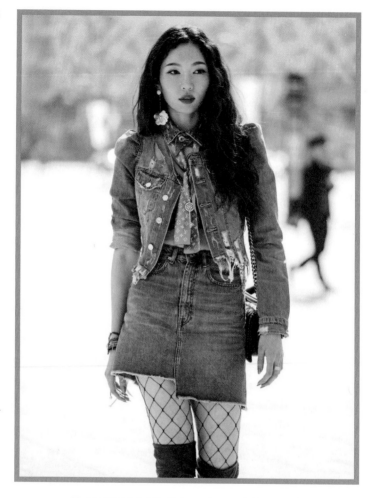

Above: A fashion enthusiast wearing a matching cut-out
denim ensemble paired with fishnet stockings.

Opposite: Seoul Fashion Week emerges as a global cultural nexus,
attracting international guests and spectators who converge at
DDP to create a vibrant fusion of diverse influences.

An intriguing trend that has evolved throughout the years is cultural dressing, with attendees from across the globe adorning themselves in their national attire – think Koreans donning modern hanboks, Indians showcasing vibrant saris, Japanese gracing the scene in vibrant kimonos, and Chinese participants making a statement with the stunning qipao, to name just a few. This phenomenon not only serves as a powerful reminder to international communities of their rich backgrounds, but also aspires to share these diverse cultural expressions with the world. As street photographers eagerly vie for snapshots of the most exceptional styles converging in Seoul, the scene truly comes alive with a celebration of global fashion.

Embracing this platform, daring hair colours, makeup and attitudes flourish, creating an environment where bolder expressions are not only welcomed but embraced, making Seoul Fashion Week an inclusive gathering that welcomes both local and international crowds.

ACELESS FASHION

One of the most striking features of Seoul Fashion Week is its all-encompassing models. The catwalks are not merely dominated by young and pretty faces; instead, beauty standards and ageist stereotypes are blurring thanks to the participation of models who span the generations. From four-year-old mini fashionistas to 60-plus seniors, models of all ages, sizes and colours are making statements and challenging antiquated notions of fashion. Senior models are breathing new life into the industry, often adorning the covers of popular magazines and gracing TV commercials, a less frequent sight elsewhere in the world.

The New Grey, a senior model agency, is making waves by "encouraging ageing models to live young and feel cool, blurring the lines between generations and opening up unprecedented opportunities in the fashion industry," says Kwon Jung-hyun, its CEO. With a focus on showing off the different charms and distinct personalities of senior models, many are thriving, now serving as brand ambassadors for companies specializing in beauty, fashion, technology, automobiles and more. "I came up with the name, 'The New Grey' because I didn't want to use 'senior' or 'silver' to connote old," he said in an interview for this book.

A distinctive aspect of Seoul Fashion Week and the broader Korean fashion industry lies in its embrace of senior models, who effortlessly embody brands with a blend of cool charisma and timeless style.

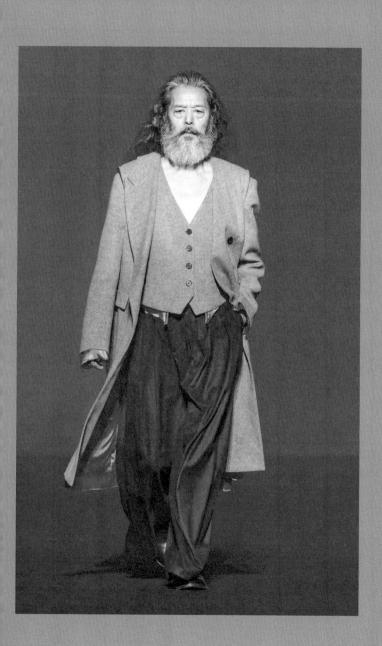

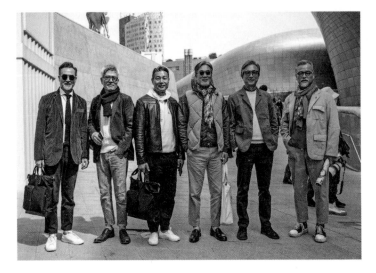

The New Grey stands as a pioneering model agency, boldly championing senior models and challenging conventional norms within the industry.

Ageing is inevitable, but for this agency the 60s are the new 20s. The goal, however, is to not make senior models look young. They want to show off the different charms of these models and make their strong presence felt in an industry that often discriminates against age. "I think that grandmothers and grandfathers are cool," Kwon emphasized. "Just as foreign models are active in Korea, I dream of a world where Korean senior models are also active in foreign countries."

On the other side of the spectrum, child models are also trying to make a mark in the fashion scene. This is evident every Seoul Fashion Week, where throngs of kids gather with their stage mums in tow – not for a playdate but to get photographed outside one of South Korea's most anticipated events. In front of every little toddler and his or her mini posse are professional photographers and onlookers with

their cameras to capture every cute gesture. What makes this scenario more fascinating is that the kids seemed completely unfazed by all the attention, as they masterfully pose, smile and show off their well-coordinated outfits with the ease and confidence of veterans.

This is the new generation of street-style stars: Seoul's most stylish kids, who defy the "normal" code of children's clothes, and the senior models who prove that great style knows no age.

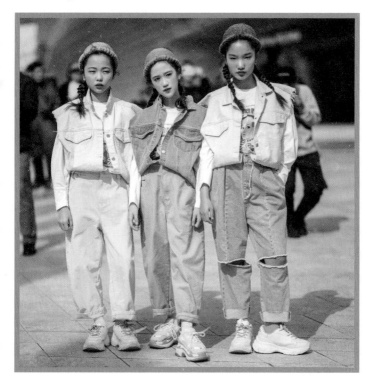

Seoul Fashion Week opens its doors to aspiring talents of all ages to participate in the fashion festivities and creating a platform for the stars of the future.

chapter 8

THE RISE OF
K-BEAUTY

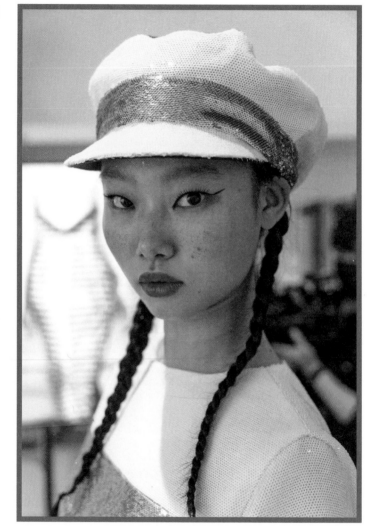

Supermodel Yoon Young Bae prepares backstage prior to the
Miss Gee Collection show in a sun-kissed makeup look that fits
the brand's nautical theme for Spring/Summer '21.

HIGHLIGHTING KOREAN SKIN CARE

Discussing Korean trends without acknowledging K-beauty would be a grave oversight. According to a market research report from *Globe Newswire,* the K-beauty products market is on track to reach a staggering $13.9 billion globally by 2027. To put this into perspective, in 2019, the global K-beauty products industry already raked in an impressive $10.2 billion, and this figure is projected to skyrocket to $13.9 billion by 2027.

The global popularity of K-pop has significantly contributed to the growth of the K-beauty industry and makeup trends. As K-pop gains a broader audience, the fascination with Korean beauty has led to increased demand for K-beauty products and inspired makeup enthusiasts worldwide to mimic the iconic looks of K-pop idols.

However, attributing this immense success solely to hallyu would be an oversimplification. Looking at it closely, the Korean beauty aesthetic can also be closely related to the *kku-an-kku* fashion mindset, where beauty is made to look effortless even if it means doing a meticulous skincare regimen religiously, as much as the famous Korean 10-step beauty routine.

Korean beauty products revolve around a proactive approach to achieving flawless, clear skin – a perfect canvas for light makeup. These high-quality products are precisely crafted to address a spectrum of skin concerns, all while prioritizing the maintenance of healthy skin. The diversity and innovation behind K-beauty products ensure their continued dominance

in the market, and their branding and presentation are thoughtfully designed to captivate consumers and cultivate loyalty.

This philosophy also extends to Korean makeup products and styles. The preference here lies in subtle, feature-enhancing looks, favouring simplicity over heavy makeup applications. The Korean approach to makeup aims not to conceal but to accentuate one's natural beauty. In short, Korean beauty, whether in skincare or makeup, is an art that celebrates and elevates individual charm.

In an exclusive interview for this book, Valentina Chang, an internationally acclaimed makeup artist based in Seoul, outlined the distinctive differences between Korean and Western makeup outlooks. "Korean base makeup revolves around achieving a natural, healthy skin appearance, while maintaining light, straight brows. The pivotal technique lies in emulating hair strokes for the brows," she emphasized. Furthermore, she pointed out that Koreans opt for blush placement a bit higher on the cheekbones to radiate a fresh, youthful glow. In terms of lip trends, the gradient, velvet and blurry lip finishes reign supreme.

Conversely, in the Western makeup arena, bold looks characterized by full coverage, intense contouring and glamorous aesthetics take precedence, often influenced by social media influencers. Chang noted, "The pursuit of a naturally enhanced look through makeup is the main idea of Korean beauty, encapsulating a uniquely refreshing concept. It demands both skill and restraint."

A daring eye-makeup aesthetic paired with understated lipstick, a prevalent trend frequently observed on Korean runways, showcases a perfect balance of audacity and subtlety. (Photo by Kathy Alcova, Makeup by Valentina Chang, Model: Shin Qian Chew)

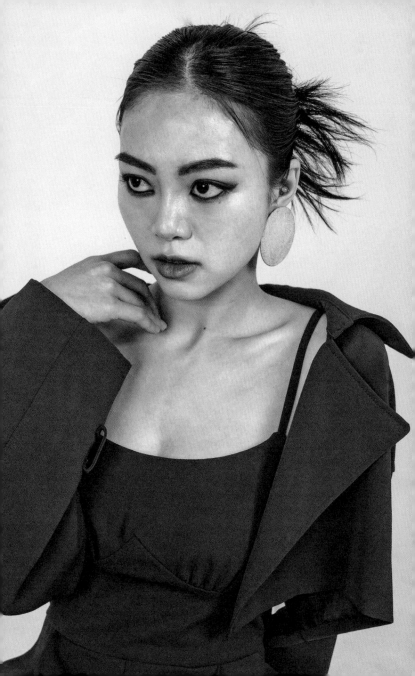

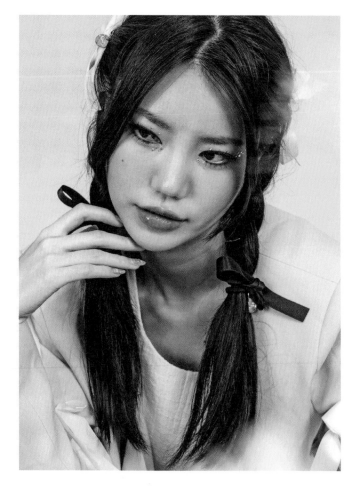

Above: The K-pop makeup style frequently features the use of crystal and shiny embellishments, adding a touch of glamour and vibrancy to the look. (Photo by Kathy Alcova, Model: Eva Leeyoung)

Opposite: Everyday makeup in Korea accentuates a natural, radiant complexion, placing emphasis on enhancing one's inherent beauty with a luminous glow. (Photo by Kathy Alcova, Makeup by Valentina Chang, Model: Kim Natalia)

Now, let's delve into three captivating makeup trends that have swept Korea's social media, K-pop scene and runways. First is the "caramel blush" trend, which showcases radiant skin sporting a sun-kissed glow achieved through the subtle application of a light brown blush with warm undertones.

Next up, we have the avant-garde, fashion-forward look, characterized by striking eye makeup that effortlessly elevates any outfit. On the high-fashion runways, this aesthetic is often paired with edgy styles from renowned Korean designers.

Lastly, the ever-charming K-pop look, frequently donned by Korean girl groups, is a trend that is often emulated by content creators from around the world. The highlight of this trend lies in the sparkling crystal gems adorning the eyes, creating an arresting, sophisticated yet cute allure. The rest of the look remains minimalist, featuring glossy lips, semi-matte foundation and understated blush to complete a picture of effortless elegance.

THE FUTURE OF HANBOK AND KOREAN DESIGN

THE HANBOK RENAiSSANCE

With Korea being well-known for its innovation in fashion and beauty comes a drawback: the seeming decline of the hanbok. Traditionally reserved for special occasions, these elegant garments are often handed down through generations or received as wedding gifts. However, even the tradition of wearing hanbok on holidays seems to be fading. Practicality and the pace of contemporary life have led many women to forgo hanbok, while men also rarely don the attire, except for the occasional photo session at hanbok rental places, which is also becoming less common, especially among younger generations.

Seo Kyoung-duk, a publicist and professor at Sungshin Women's University, surveyed young Koreans in Seoul and Gyeonggi Province. The results, as published in the *Korea Times*, were telling: 84.7 percent of respondents in their 20s and 30s did not wear hanbok during Seollal or Chuseok holidays. Reasons ranged from discomfort to expense, difficulty in maintenance and lack of trendiness.

To counter this trend, the South Korean government has taken steps to preserve the spirit of the hanbok. In 1996 the Ministry of Culture, Sports and Tourism introduced Hanbok Day to encourage citizens, particularly the youth, to wear the hanbok. Moreover, the Korean Cultural Heritage Administration designated *"hanbok saengwal"* as National Intangible Cultural Heritage. This initiative aims to promote not only wearing and creating hanbok but also to foster appreciation for the intangible aspects that define hanbok.

Amidst declining interest in hanbok among the younger generation, Korean designers have embarked on the challenging task of revitalizing and modernizing this iconic attire while preserving its cultural significance. Here are some of the designers who have taken on this challenge.

The *jeogori*, the traditional top of a hanbok, undergoes a contemporary transformation in the hands of designer LEESLE, infusing the garment with a modern touch.

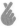

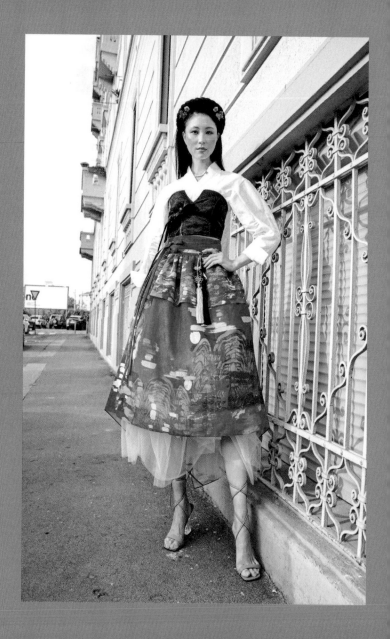

THE MODERN HANBOK: LEESLE

"It must be in my genes to become a hanbok designer," says Hwang Yi-seul, CEO and designer of the modern hanbok brand LEESLE, in an interview for this book. Her journey into fashion began with a simple idea: wearing traditional clothing at a cosplay festival during her university days. That day marked her love affair with hanbok, leading her to create her own as a hobby. However, her connection to hanbok turned out to run even deeper than she realized. Her mother revealed, "I made hanbok when you were in my belly!" It turns out her mum used to be a hanbok maker before marriage.

Hwang established her atelier in Jeonju, a traditional city known for its hanbok rental shops catering to tourists seeking the hanbok experience. She also has an atelier in Seoul. LEESLE's mission is to transform hanbok from a mere tourist attraction or occasional wear into a daily fashion choice. "When people open their closets, they usually think, 'Should I wear a T-shirt, blouse or dress?' I hope one day, they will think, 'Should I wear a hanbok today?'" Hwang envisions.

One of the latest iterations of the hanbok she has created is the matching denim set, which retained the shape and design of the *chima* and *jeogori* for women, and the *paji* for men, while using denim as fabric.

The components of the hanbok experience an avant-garde transformation, pushing traditional boundaries and infusing the ensemble with a cutting-edge flair.

The Future of Hanbok and Korean Design

Recently, LEESLE created a sub-brand called LEESLETAGE, a combination of the words "LEESLE" and "heritage". Here, she incorporates *hangul* (Korean writing) and Korean characters in prints, as well as Korean artworks and the symbols found in the national treasures of Korea.

One of the fashion lines, dubbed "Yongan Series", highlights the dragon pattern of Gonryongpo, a costume worn by kings of the Joseon dynasty. The line featured tank tops worn with hanbok-inspired jackets, jogger pants with the *norigae* (braided silk tassel accessory threads) and hoodie jackets emblazoned with the dragon prints once exclusive to Korean royalty. Hwang even reintroduced the *dapho*, a vest from the Joseon dynasty, making it a modern festival or beachwear piece. "It is a representative example of reinterpreting traditional coats into hip fashion."

> **"Hanbok should be approached as a natural lifestyle and daily fashion, not an outfit worn with a sense of obligation."**

From strictly formal events to a casual day out, the tennis courts and even the gym, the hanbok has come a long way, with its versatility expanded and integrity kept intact. Hwang's current motto is "Oh! Hanbokhan life" (a blend of hanbok and *haengbok*, meaning "happy"). "This means that hanbok should be approached as a natural lifestyle and daily fashion, not an outfit worn with a sense of obligation," Hwang says.

LEESLE gives the hanbok a youthful makeover as denim pieces, catering to the tastes of the younger market and adding a casual and contemporary touch to this traditional attire.

The Future of Hanbok and Korean Design

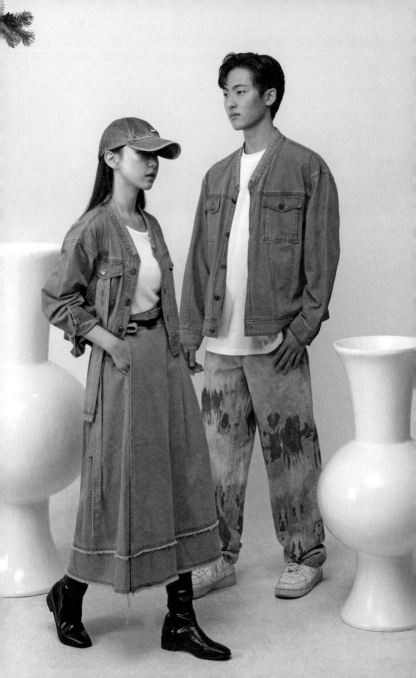

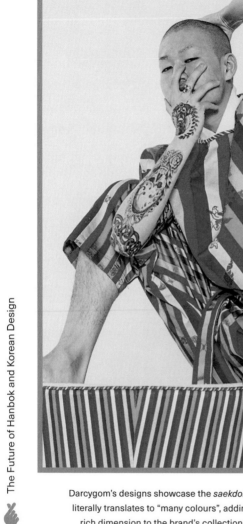

Darcygom's designs showcase the *saekdong*, a traditional fabric that literally translates to "many colours", adding a vibrant and culturally rich dimension to the brand's collection. (Photo by Jung Jihoon)

THE SUSTAINABLE HANBOK: DARCYGOM

With a profound hanbok influence, adeptly harmonizing clean minimal lines with quirky designs, and embracing a blend of feminine chic and masculine cool styles in gender-fluid fashion, Korean fashion has risen to global prominence. This ascent owes much to the South Korean government's nurturing of young talent through diverse design programmes. Beth Seung-ju Lee, the creative force behind the Darcygom brand, is one example of the immense impact of this support on burgeoning talents.

Returning to Korea after 15 years abroad, Beth delved into sewing at the Gwangjang Market, a hub famous for hanbok production. Engaging in initiatives like the "Youth Sewing Academy" by Seoul city and "Me Me Project" by the Seoul Design Foundation, her creative journey gained momentum. Inspired by tradition and innovative local programmes, Darcygom took shape.

The name Darcygom stands as a unique fusion of meanings. "Darcygom" originates from the native Korean word *darcygeum*, signifying "yet again". It takes a further twist by incorporating Mr Darcy, Jane Austen's iconic character, and *Gom*, the Korean word for "bear". This brand name captures the meaning of a creative journey that intertwines Korean traditions, sustainability and contemporary fashion. The concept of "yet again" symbolizes the revival of old practices and materials in a fresh, innovative light. This juxtaposition of

old and new is reflected in the brand's motto: "Korean tradition meets Sustainable Fashion".

The founder's commitment to sustainability stems from an intrinsic connection between design and environmental consciousness. Beth frequently observed garbage trucks carrying loads of unused fabric scraps from sewing factories, and realizing the impact of neglected textiles on the environment she decided to discover alternative materials for creating unique garments. This led to unexpected collaborations, such as a partnership with non-fashion brands, breathing new life into discarded materials.

One of Darcygom's projects involves preserving the dying art of *saekdong*, a traditional Korean multi-stripe fabric. Recognizing its fading prominence, the brand embarked on a crowdfunding campaign to create *saekdong* sneakers. By weaving heritage into modern designs, Darcygom raises awareness about disappearing crafts and promotes their significance. "I pay great attention to material selection, whether they embody Korean heritage or fall under sustainable fashion," Beth shares. "Rather than copying the exact symbols or designs from traditional clothing from the past, I wanted to tell my own story through my garment."

The brand's aesthetics are a harmonious blend of tradition and modernity. Embracing the aesthetic of "Korean Heritage Core", which respectfully modernizes age-old traditional craftsmanship and materials, Darcygom's designs resonate with a global audience. They seamlessly incorporate elements from traditional hanbok, vibrant *saekdong* fabric and genderless, quirky street style. This unique fusion captures the spirit of contemporary Korean fashion, blending history with a modern twist.

Darcygom's couples' vibrant hanbok ensemble is a testament to artistic collaboration, intertwining the creative visions of artist Junghwan Cho and illustrator Nodab into a harmonious and visually stunning design.

The Future of Hanbok and Korean Design

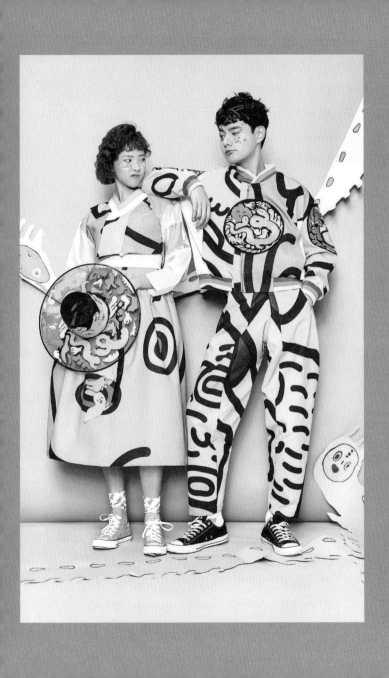

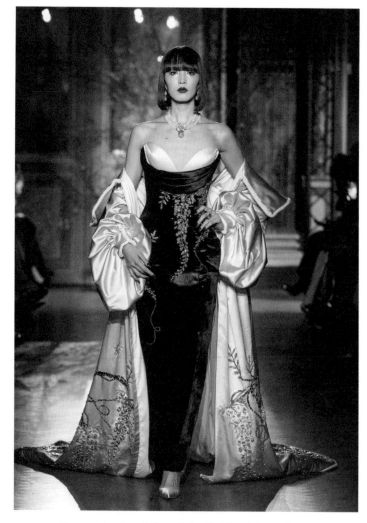

Renowned couture designer Sohee Park is celebrated for her sophisticated creations, which draw inspiration from nature and captivate the attention of celebrities who seek her elegant designs for red carpet events, under the brand name MISS SOHEE.

KOREAN COUTURE ON THE RED CARPET: MISS SOHEE

Couture designer Sohee Park understands the importance of timing. In 2012 a random encounter with a Chanel fashion show on TV ignited her interest in fashion, propelling her from Korea to Central Saint Martins, London. Under the guidance of Marc Jacobs and Holly Goddard, she refined her skills, blending sculptural elements with fluid silhouettes. Another stroke of fate presented itself in 2020, during the global COVID-19 pandemic. Lockdowns and event cancellations prevailed worldwide. Undeterred, Sohee created her debut collection for her eponymous label, MISS SOHEE, titled "The Girl in Full Bloom", within her modest London flat. The absence of year-end shows didn't halt her determination.

"Making that collection was incredibly difficult," she revealed in an interview with *Paper* magazine. With businesses shuttered and deliveries delayed, she turned to online platforms, even sourcing fabric remotely. "I wanted to challenge myself, and I've always been so ambitious." Unlike her Korean peers who returned home when the school shut down, Sohee remained in London, her commitment unwavering.

She unveiled her graduation collection, which featured structural floral ensembles symbolizing the journey from girlhood to womanhood, through Instagram. Striking images of model Georgie Hobday adorned in opulent couture gowns boasting exaggerated shapes, iridescent hues, gradient tones

The Future of Hanbok and Korean Design

and intricate floral motifs resonated as a source of escapism during dreary times and rapidly went viral.

Perfect timing seemed to be on her side. Esteemed publications and fashion media reached out, with *LOVE* magazine showcasing her work on their cover. Opportunities cascaded from there, as conceptual designer Christian Cowan proposed a collaboration for his Spring 2021 collection. Soon after, Sohee made her fashion week debut at Milan Fashion Week in February 2022, supported by Domenico Dolce and Stefano Gabbana of Dolce & Gabbana.

Her flair for graceful gowns, often paired with meticulously designed headdresses, grabbed the attention of celebrity stylists. Her dresses graced red carpets, with stars like Miley Cyrus, Cardi B, Naomi Campbell, Halle Bailey and Ariana Grande donning her creations at events such as the Met Gala, amfAR gala, VMAs, and the Vanity Fair Oscar Party.

Amid her global triumphs, Sohee remains rooted in her Korean heritage, infusing it into her designs. For her second collection she drew inspiration from Jeju Island, crafting moulded gowns reminiscent of shells, embellishing with pearls, and incorporating voluminous elements that evoke mystical sea creatures. Fondly recalling her time spent at her grandmother's seaside residence near Jeju Island, she shared with *Paper*, "It's a very special island that we all love in Korea and it's a really beautiful place."

Fashion critics soon commended her meticulous attention to detail, skilful construction that complements the human form, and her gift for infusing fantasy into every piece. Recognized as the third recipient of the prestigious Goodwood Talent in Fashion Award, she also designed three gowns for the occasion. Clearly, Sohee Park's journey has only just begun.

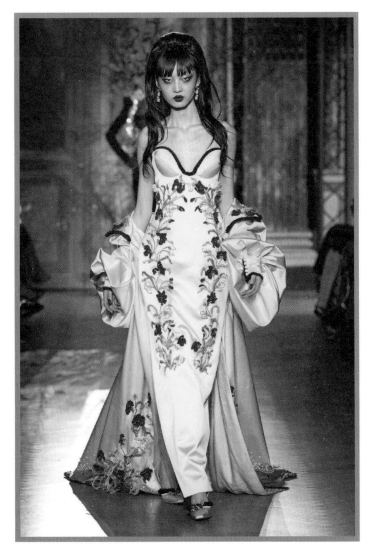

A radiant yellow dress takes centre stage at Paris Haute Couture Week for MISS SOHEE's Spring/Summer '23 collection.

The Future of Hanbok and Korean Design

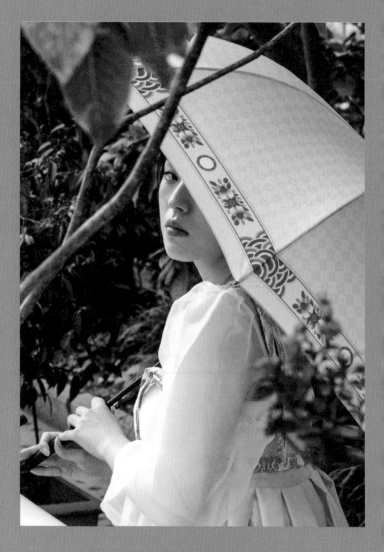

Mimidar, the brand that seamlessly weaves traditional Korean designs into everyday products, transforms ordinary items, like umbrellas, into carriers of Korean culture.

KOREAN CULTURE IN YOUR POCKET: MIMIDAR DESIGN

In souvenir shops, traditional cultural products like magnets, keychains, and mugs bearing images of tourist destinations are typically gifts for young travellers' parents. One lifestyle brand sought to revolutionize this concept, expanding the product range while infusing practicality and style into once purely decorative items. The symbolic designs of ancient artifacts found new life in mobile phone, AirPod and iPad cases, tote bags and umbrellas, reimagined for the younger generation: enter Mimidar, a brand that rejuvenates traditional imagery, making it both trendy and refreshing.

The brand launched the crowdfunded Goryeo Celadon in 2020, which is a mobile phone case collection selected by the National Museum of Korea as the official museum merchandize. Among the artifacts of the Goryeo dynasty (a Korean state founded in 918) lies a blue pottery piece adorned with an inlaid crane and cloud motifs, symbolizing longevity and fortune. Founder and CEO of Mimidar Hailey Han perceived deeper beauty and meaning within this artifact, driven by the desire to share it with the world. "I wanted to carry it around every day and show it off," she expressed.

Mimidar's story resonates as the culmination of the sales influence of the hallyu phenomenon, spurred by consumers' adoration for Korean culture and the sway of K-pop stars. Visitors to the National Museum of Korea sought souvenirs of their cultural immersion, and Mimidar's offering became

The Future of Hanbok and Korean Design

Mimidar's phone cases and AirPod cases have become standout favourites, boasting intricate Korean traditional prints.

a sensation. After its debut in the museum shop, over 20,000 pieces were sold in two months. Furthermore, a huge turning point arrived when rapper RM of BTS posted a selfie with a Celadon phone case. The ensuing overseas inquiries propelled sales to 50,000 pieces, underscoring K-pop's power. "Thanks to RM, we received many overseas requests. We launched an English website for our online shop in 2021, earlier than planned, to meet high demand," Han recounted.

Han's creations not only revive national treasures but also honour traditional Korean architecture. The *dancheong* umbrella, inspired by colouring on wooden structures, symbolizes yin, yang and nature elements. This idea struck Han as she saw raindrops falling from the umbrella's edge, reminding her of Korean palace roofs.

Mimidar brand is always looking back to the past so it can share Korean culture for many futures to come. Han explains, "Old objects, patterns and designs carry meaningful and captivating stories. Even in the tiniest details, we glimpse our ancestors' philosophy and wisdom. I aim to uncover hidden details in familiar yet overlooked things, sharing them with the world."

CHALLENGES AND ENDLESS POSSIBILITIES

Describing the hanbok revival as "Beopgochangshin," a term suggested by hanbok designer Kim Hye-soon, encapsulates its essence: staying true to roots while embracing evolution, promising an array of fresh hanbok interpretations.

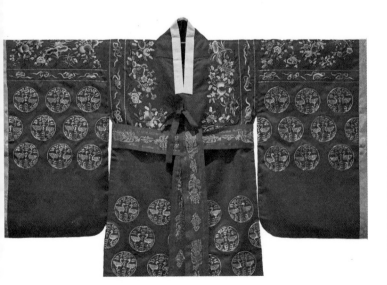

The *hwarot*, a meticulously embroidered traditional Korean garment, graced the attire of royal women exclusively during the Goryeo and Joseon eras for ceremonial occasions. Over time, it transitioned to being worn by commoners, particularly for weddings.

The Future of Hanbok and Korean Design

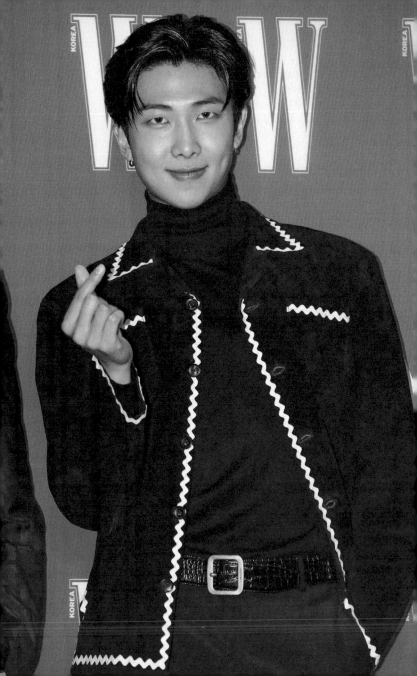

Modernizing hanbok and Korean design to resonate with younger generations is vital, but it poses a multifaceted challenge. The task extends beyond mere aesthetic alterations. Designers must navigate both tradition and innovation, while seamlessly merging timeless elements with contemporary sensibilities. How can designers cater to a broader audience while preserving the attire's integrity and heritage? How can they breathe new life into the hanbok while respecting its historical significance, all while ensuring it remains relevant in the eyes of younger generations?

Meanwhile, Korean celebrities taking on roles as global ambassadors for international brands have disrupted the once Western-centric fashion standards, simultaneously opening up new opportunities. However, this shift also presents challenges within the local fashion ecosystem. Korean fashion designers are increasingly eyeing expansion overseas and seeking global stockists as well. How can both entities champion Korean culture while retaining their identity amidst a more globalized future?

Perhaps this question finds its answer in living examples.

Leader of global sensation BTS, RM, whose given name is Kim Namjoon, goes beyond his role as a K-pop singer and rapper, turning his passion for the arts into a mission to champion South Korean artists globally. He received acclaim from the Cultural Heritage Administration in South Korea for his 100 million won ($71,590) donation to preserve and restore overseas Korean cultural artifacts.

BTS leader RM is recognized for his dedicated efforts in preserving Korean artifacts and advocating for galleries worldwide. He uses his massive influence on Instagram to connect with millions of followers and fans, fostering a global appreciation for Korean cultural heritage.

With 44 million Instagram followers, RM continues to excite fans with his art explorations, emphasizing the importance of his generation taking an interest in fine art and antiques. He told *Vogue* for his cover interview, "I think that people of my generation especially need to take interest in Korean modern art and antiques."

His dedication extends to Korean fashion, contributing 100 million won ($75,000) to restore the *hwarot*, a traditional Korean bridal costume, which was showcased at the National Palace Museum in Seoul. Owned by LACMA (Los Angeles County Museum of Art), this hanbok is an embroidered royal bridal attire from the 1392-1910 Joseon Dynasty.

RM exemplifies the essential balance required between contrasting yet equally significant realms: the intersection of tradition with modernity, and the interplay between exclusivity and accessibility.

As he showcases the behind-the-scenes efforts in promoting Korean heritage, another Korean celebrity is taking center stage to illuminate their cultural richness on the global platform.

At her debut on the Hollywood red carpet during the 74th Primetime Emmy Awards, Jung Ho-yeon sported a short wavy bob hairstyle, accentuating it with a floral hairpin at the centre of her parting. This choice appeared to pay homage to Korea's Joseon-era *baetssi daenggi*, a traditional ornament placed atop a woman's parted hair, typically adorned by young women before marriage.

Her blend of international red carpet glamour and Korean cultural heritage at international events exemplifies a harmonious coexistence between patronizing international brands and celebrating Korean culture. Her choice to incorporate traditional Korean elements into her high-profile

appearances serves as a powerful statement. It signifies that there need not be a separation between global fashion and cultural identity; rather they can create a harmonious and dynamic relationship. In an increasingly interconnected world, this approach reminds us that cultural preservation and globalization can go hand in hand, enriching the fashion landscape and promoting cultural diversity.

Squid Game star Jung Ho-yeon shines on the red carpet, beautifully integrating traditional Korean hairstyles in her two red carpet appearances, effortlessly bridging modern allure with cultural pride.

[1] Lingua Asia (2023 February 17). "55 Cool Korean Slang Words You Need to Know in 2023." Retrieved from https://linguasia.com/korean-slang

[2] AnOther. (2022, September 23). "How Korean Fashion and Culture Took over the World." Retrieved from https://www.anothermag.com/fashion-beauty/14380/how-korean-fashion-and-culture-took-over-the-world-hallyu-the-korean-wave

[3] The New York Times (2022, April 9). "One Garment's Journey Through History." Retrieved from https://www.nytimes.com/2022/04/09/style/one-garments-journey-through-history.html

[4] Victoria and Albert Museum. "Hanbok – traditional Korean dress." Retrieved from https://www.vam.ac.uk/articles/hanbok-traditional-korean-dress#:~:text=Conveying%20social%20identity%20through%20hanbok,roles%20to%20achieve%20societal%20harmony.

[5] The Korea Herald (7 July 7 2022). "Hanbok represents the spirit of Korean people throughout history." Retrieved from https://www.koreaherald.com/view.php?ud=20220721000849

[6] The Korea Times (12 July 2007). "Renaissance of Hanbok." Retrieved from https://www.koreatimes.co.kr/www/culture/2023/08/135_6384.html

[7] Korea.net (25 February 2021). "Korean accessories from Joseon Dynasty era." Retrieved from https://www.korea.net/NewsFocus/HonoraryReporters/view?articleId=195273

[8] Korea JoongAng Daily (11 April 2022). "More than just clothing, hanbok retains cultural significance." https://koreajoongangdaily.joins.com/2022/04/11/culture/koreanHeritage/hanbok-korean-traditional-clothes-national-intangible-cultural-heritage-hanbok/20220411152834343.html

[9] Asia Society. "Hanbok Part 1: The Origin and the History." Retrieved from https://asiasociety.org/korea/hanbok-part-1-origin-and-history.

[10] The Korea Times (22 March 2020). "Designer, who redefined hanbok, dies at 85." Retrieved from https://www.koreatimes.co.kr/www/culture/2022/06/262_286591.html

[11] History (17 July 2023). "How Japan Took Control of Korea." Retrieved from https://www.history.com/news/japan-colonization-korea

[12] The Review of Korean Studies (March 2011 March). "Joseon in Color: Colored Clothes Campaign" and the "White Clothes Discourse" Retrieved from https://accesson.kr/rks/assets/pdf/7716/journal-14-1-7.pdf

[13] Chosun Ilbo (12 August 2015). "[70 years of clothing] Japanese style in the 40s, American military relief in the 50s..." Retrieved from https://www.chosun.com/site/data/html_dir/2015/08/04/2015080401714.html

[14] The Wall Street Journal (31 October 2013). "South Korea's Fashion Doyenne." Retrieved from https://www.wsj.com/articles/BL-SJB-12677"

[15] The Korea Times (11 March 2022). "Seoul's street fashion changes with Korea's dynamic modern history."

Retrieved from https://www.koreatimes.co.kr/www/culture/2023/08/135_324103.html

[16] The Los Angeles Film School. "A Brief History of K-pop." Retrieved from https://www.lafilm.edu/blog/a-brief-history-of-kpop/

[17] *Korea JoongAng Daily* (12 March 2023). "From K-pop to a 'Hallyu' economy." https://koreajoongangdaily.joins.com/2023/03/12/opinion/columns/Kpop-Kculture-Hallyu/20230312200322387.html

[18] The *Korea Times* (30 March 2016). "Laziness made Korean beauty industry successful." Retrieved from https://www.koreatimes.co.kr/www/culture/2023/08/135_201513.html

[19] Yonhap News Agency. (18 April 2023). "BLACKPINK sets Guinness record for most-viewed music channel on YouTube." Retrieved from https://en.yna.co.kr/view/AEN20230418004400315#:~:text=The%20latest%20achievement%20added%20to,British%20and%20U.S.%20album%20charts.

[20] KOFICE 2022 Global Hallyu Trends. Retrieved from file:///Users/theo/Downloads/2022%20Global%20Hallyu%20Trends.pdf

[21] *Korea JoongAng Daily* (18 July 2023). "Blackpink's Coachella hanbok designers blend old and new." Retrieved from https://koreajoongangdaily.joins.com/2023/06/18/culture/koreanHeritage/coachella-blackpink-blackpinkjennie/20230618150208815.html

[22] *Korea JoongAng Daily* (5 January 2017). "Still an intermediary in fashion?" Retrieved from https://koreajoongangdaily.joins.com/2017/01/05/fountain/Still-an-intermediary-in-fashion/3028285.html

[23] Fashion United (24 March 2023). "How the Korean Wave took over the Western fashion world." Retrieved from https://fashionunited.uk/news/business/how-the-korean-wave-took-over-the-western-fashion-world/2023032468652

[24] *Korea JoongAng Daily* (22 March 2023). "Designer Lie Sang Bong to show his Klimt-inspired collection in Vienna." Retrieved from https://koreajoongangdaily.joins.com/2023/03/22/culture/artsDesign/lie-sang-bong-the-kiss-gustav-klimt/20230322164824746.html

[25] The *Korea Herald* (24 March 2019). "Creating tailored suits artistic, elegant and fun." Retrieved from https://kpopherald.koreaherald.com/view.php?ud=201903241528324693672_2

[26] The *Korea Times* (11 October 2018). "Hera Seoul Fashion Week gives local designers global reach." Retrieved from https://www.koreatimes.co.kr/www/culture/2022/04/199_256807.html?RD

[27] Global Newswire (22 February 2021). "K-beauty Products Market to Reach $13.9 Bn, Globally, by 2027 at 9.0% CAGR: Allied Market Research." Retrieved from https://www.globenewswire.com/en/news-release/2021/02/22/2179695/0/en/K-beauty-Products-Market-to-Reach-13-9-Bn-Globally-by-2027-at-9-0-CAGR-Allied-Market-Research.html.

[28] The *Korea Times* (5 February 2016). "Young Koreans reject holiday hanbok." Retrieved from https://www.koreatimes.co.kr/www/nation/2022/09/113_197456.html

iNDEX

CREDITS

The publishers would like to thank the following sources for their kind permission to reproduce the pictures in this book.

8 Melodie Jeng/Getty Images, 10 Chung Sung-Jun/Getty Images, 11 Jay Lim, 12 Justin Shin/Getty Images, 15 Justin Shin/Getty Images, 19 Heritage Art/Heritage Images via Getty Images, 20 Universal History Archive/Universal Images Group via Getty Images, 23 Pictures From History/Universal Images Group via Getty Images, 24, 26 RUNSTUDIO/Getty Images, 27 Linda Grove/Getty Images, 28 Plan Shoot/Imazins/Getty Images, 32 Public Domain, 34 Landmark Media/Alamy Stock Photo, 36 Associated Press/Alamy Stock Photo, 39 Chung Sung-Jun/Getty Images, 41 Kristy Sparow/Getty Images, 43 JSK Colorization, 44 Lisa Maree Williams/Getty Images, 47, 49, 51 Park Kyungil, 53 Rindoff/Dufour/French Select/Getty Images, 57 Swan Gallet/WWD via Getty Images, 58 The Chosunilbo JNS/Imazins via Getty Images, 61 Emma McIntyre/Getty Images for WarnerMedia, 62 Kevin Mazur/Getty Images for The Recording Academy, 66 Kevin Mazur/MG23/Getty Images for The Met Museum/Vogue, 68 Frazer Harrison/Getty Images for The Recording Academy, 69 Stephane Cardinale - Corbis/Corbis via Getty Images, 70 Claudio Lavenia/Getty Images for Bulgari, 75 Justin Shin/Getty Images, 76, 79 Photo provided courtesy of designer Kim Seo Ryong, 80, 83 Photo provided courtesy of designer KimheKim, 84 Richard Bord/Getty Images,

85, 87 Photo provided courtesy of designer Bmuet(Te) Byungmun Seo, Jina Um of, 88, 90 Photo provided courtesy of Greedilous designer Younhee Park, 92 Photograph by Choi Song/ 3D Graphic artist: Hyun Ho Park, 93 Photo provided courtesy of designer Hannah Shin, 94 Photo provided courtesy of Pale Turquoise designer Park Lyn Jun, 97 Photo provided courtesy of Pale Turquoise designer Park Lyn Jun, 100 Jean Chung/Getty Images, 101, 103, 104 Justin Shin/Getty Images, 107 Chung Sung-Jun/Getty Images, 108 Justin Shin/Getty Images, 109 Han Myung-Gu/WireImage/Getty Images, 111 Hanna Lassen/Getty Images, 114 Jay Lim, 115 Christian Vierig/Getty Images, 116 Matt Jelonek/WireImage/Getty Images, 117 Jay Lim, 118 Christian Vierig/Getty Images, 119 Hanna Lassen/Getty Images, 121 Justin Shin/Getty Images, 122 Jean Chung/Getty Images, 123 Christian Vierig/Getty Images, 126 Justin Shin/Getty Images, 129, 130, 131 Kathy Alcova, 135, 137, 139 Photo provided courtesy of LEESLE designer Hwang Yi Seul, 140 Photo by Jung Jihoon, 143 Photo by Cho Junghwan and illustrator Nodab, 144, 147 Victor Virgile/Gamma-Rapho via Getty Images, 148, 150 Photo provided courtesy of MIMIDAR designer Hailey Han, 151 Jean-Pierre Dalbera, 152 Victor Virgile/Gamma-Rapho via Getty Images, 155 Momodu Mansaray/Getty Images

Designer interview Korean translation assistance:
Kim Seong Jin and Julia Zulhumor